Pictures from the Word

Marlene J. Chase

Crest Books
Salvation Army National Publications
615 Slaters Lane
Alexandria, Virginia 22313

Also by Marlene J. Chase
A Seed in the Wind (The Salvation Army, Des Plaines, IL)
The Other Side of Silence (Barbour, Inc.)

© copyright 1998 The Salvation Army

Published by Crest Books, Salvation Army National Publications
615 Slaters Lane, Alexandria, VA 22313
(703) 684-5500 • Fax: (703) 684-5539
http://publications.salvationarmyusa.org

Printed in the United States of America.

Unless otherwise noted, scripture quotations taken from the HOLY BIBLE, NEW INTERNATIONAL VERSION. Copyright © 1973, 1978, 1984 by International Bible Society.

Cover and inside photos by Diane E. Tolcher

Layout and design by Timothy Clark

Library of Congress Catalog Card Number: 98-70855

ISBN: 0-9657601-3-8

Contents

Contents

Preface

The Bible is vivid with word pictures, concrete images that bring to life spiritual ideas. God's personality is poignantly revealed in such images as a hen sheltering her chicks or as a loving father engraving the names of his children into his hands. Wisdom is compared to a good and gracious woman who invites all who will walk in the way of understanding to come and dine with her. Salt, apples, cornstalks, priceless pearls and a host of other images teach us about God and about ourselves.

Pictures from the Word addresses Scripture's frequent references to the vulnerability of man met by God's limitless and gracious provision. The illustrations are familiar metaphors such as lilies in a field, the sparrow, the rock dove and harps hanging on willow trees.

Beginning with the Scriptural image, each meditation addresses the picture's context and purpose and underlines its teachings with contemporary application. No attempt is made to draw elaborate analogies between prophecies and particu-

lar events—but to glean from Scripture's imagery practical and thoroughly biblical concepts.

This collection of fifty-six pictures appeared as separate installments in *The War Cry* over a period of several years. Arranged in four categories, this book underscores God's provision for the world and affirms his limitless grace and love:

- God's provision of himself, the divine personality
- His provision for redemption, the universal human cry
- His provision for living the Christian life in community
- His provision of comfort in suffering

May the Great Illustrator illumine our hearts and minds with his unsurpassed truth.

Lt. Colonel Marlene Chase
Alexandria, Virginia

Pictures

from the

Word

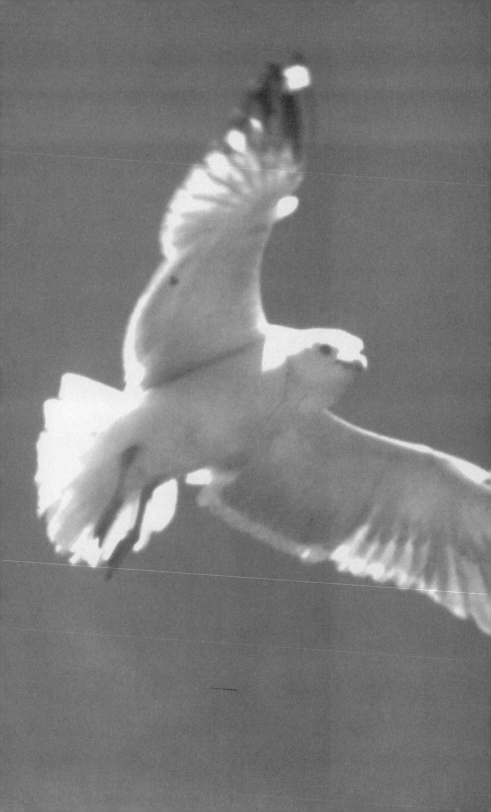

The

Divine

Personality

All Things Sacred

We delight in the many figures of speech in God's Word, in such similes and metaphors as "we all, like sheep, have gone astray" (Isa. 53:6) and "you will be a crown of splendor ... a royal diadem in the hand of your God" (Isa. 62:3). Irony, personification, paradox—these figures and more—drive God's words like arrows into our souls. But when hyperbole (exaggeration) is used, we are often caught off guard.

"Are not two sparrows sold for a penny? Yet not one of them will fall to the ground apart from the will of your Father. And even the very hairs of your head are all numbered. So don't be afraid; you are worth more than many sparrows."
Matt. 10:29-30

We're tempted to laugh at the mental image of a proud Pharisee straining a tiny gnat out of his food while gulping down a camel. The image satirizes the Pharisee's tendency to give careful attention to insignificant questions while quickly glossing over weightier matters.

The use of hyperbole can shock us into attention and teach us difficult, almost impossible-to-believe, truths. The startling "you must be born again" is like that. Its effect is dulled only by our frequent hearing of it. But for Nicodemus it was singularly poignant, bringing him almost to the point of laughter.

To imagine God counting the hairs on our heads (a number that changes daily) seems ludicrous. Yet, I believe that image was for Jesus a deliberate, careful choice. His purpose, among other things, was to teach that God is concerned about the minutia of our lives, even those details we think unimportant.

God wants us to bring before him everything that concerns us. Often we think he is only interested in things we think of as spiritual. "It is a great mistake to think that God is chiefly interested in religion," wrote William Temple.

God's plan was to bring all things in the world to cohesion in Christ, in whom "God was pleased to have all his fullness dwell ... and to reconcile to himself all things, whether things on earth or things in heaven" (Col. 1:19-20). For Christians, nothing is secular. All things are sacred and come under the scrutiny of God's amazing light.

The Psalms engage us deeply, partly because they resound with the full gamut of emotions we feel. Hebrew poets brought every thought and feeling before God with no part of their lives restricted from the expression of worship. They had the courage to admit to feelings of despair or anger, even expressing curses inwardly felt. It never occurred to them that such emotions should be denied when they met God in prayer. They did not foolishly imagine, as we sometimes do, that anything can be hidden from God who sees everything and knows us intimately. The Proverb every Jew memorized reminds us, "The

eyes of the Lord are everywhere, keeping watch on the wicked and the good" (Prov. 15:3).

God wants us to discuss everything with him, to be close enough that we filter every thought, every emotion, every subtlety through him. "Do not be anxious about anything," the Apostle Paul writes, "but in everything, by prayer and petition, with thanksgiving, present your requests to God" (Phil. 4:6). Similarly, God urges, "Cast all your anxiety on him because he cares for you" (1 Pet. 5:7).

My mother believed strongly that everything that happened to her and everything that didn't happen was orchestrated by the loving, all knowing God she served. With her there were no small matters. She prayed over an ailing refrigerator, knowing there was no money in the budget for a replacement. When she mislaid her glasses and thus could not have her daily quiet time with her Bible and devotional books, she made it a matter of prayer.

I sometimes kidded her about this, secretly wondering if God were really concerned about such things. She was quick to thank God too when he answered her prayers—small and large. But weren't those just coincidences? Wouldn't she have eventually found her glasses if she hadn't prayed? She reminded me of the saint who said, "When I pray, coincidences happen. When I don't, they don't."

Not only is God interested in the most minute detail of our lives, he's concerned even about things that we think are unimportant now. One day I might indeed be concerned over the loss of my hair. Like my friend, diagnosed with cancer, who sees it thinning daily before her eyes. The hyperbole can help us realize that he sees the end from the beginning, that he cares not only about what concerns us now, but about what

might happen a week or a year from now.

The hymnwriter reminds us that nothing is hidden from his sight and that we have no need to fear because his perfect love for us "casts out all fear."

> *All is known to thee, my Master,*
> *All is known and that is why*
> *I can work and wait the verdict*
> *Of thy kind but searching eye.*
> —*The Salvation Army Songbook*

An Uncommon Love

Although there is more than one interpretation of the lovely poetic Song of Solomon, the book holds much that enriches our understanding of God's world and speaks to the poet in us all. The writer of this passage compares his beloved to the wild rock dove, a bird of cliffs and ledges. A shy creature, the dove hides itself among the rocks and expresses itself in a mournful, cooing voice. We, too, behave like the dove at those times when we reach deep into the soul for purpose, for self-examination, for love.

> *"My dove in the clefts of the rock, in the hiding places on the mountainside, show me your face, let me hear your voice; for your voice is sweet, and your face is lovely."*
> Song of Solomon 2:14

It is doubtful that many of us have caught sight of a wild rock dove, but we have all seen its descendant, the city pigeon. We've watched it strutting executive style across boardwalks and felt its warm flutter over our heads as we waited for

the bus. We're aware of the damage pigeons can do to window air conditioners and to our newly cleaned suits.

We see pigeons largely as nuisances and perhaps wonder at author Eugenia Bedell's fascination with these creatures. She observes, "I wonder if anyone has ever seen a baby pigeon in New York City? Or are they hatched fully grown? ... I wonder if the pigeons in midtown Manhattan drink water, and, if so, where do they find it? ... I wonder why pigeons live in cities? ... I wonder why pigeons are so fond of air conditioners? But, pigeons, thank you for making my life so full of wonder ..."

Pigeons live in cities because a city offers cliffs and ledges. Having no natural talent for nest-building, pigeons choose a nook, a recess, an outcropping, the narrow channel between two buildings, the tin elbow of a downspout or the concrete beard of a saint.

Of course there are baby pigeons (squabs) nurtured in nests above the ground (pigeons prefer second and third floor locations), but city dwellers do not ordinarily lift their gaze above eye level. They pass by scheming, worrying, hoping, dreaming, but not looking, or at any rate, not looking up. Perhaps the rock dove's severest fault is the fact the it is so common. We do not see its silver, smooth-shaped body as beautiful or its symmetrically fanned tail-feathers as remarkable. It is a common pigeon which, far from "making our lives so full of wonder," irritates us and interferes with our progress.

"What is man that thou art mindful of him?" David pondered. One wonders if the great king of Israel meditated on this thought as he viewed the masses of men and women—people as plenteous as grains of sand on a seashore or pigeons in a city park. Did David fear that God would only consider frail humanity as ordinary, common, easy to dismiss?

Yet Scripture reminds us again and again that God sees us not only as individuals, but as wondrous and precious. As a child growing up in the city, I often looked up at thousands of tiny lighted windows behind which sat someone—so many someones. And I wondered how God could be aware of each one, let alone care deeply about that solitary form.

Sparrows were considered common in biblical times—about as common as the pigeon is now. Jesus once said to a crowd of men, women and children at his feet: "Are not two sparrows sold for a penny? Yet not one of them will fall to the ground apart from the will of your Father. And even the very hairs of your head are all numbered. So don't be afraid; you are worth more than many sparrows" (Matt. 10:29-31).

To God our faces are lovely and our voices sweet. He tells us he longs to commune with us. This is the great wonder of life, that God should long for our company. That he should desire it so much he was willing to pay the ultimate price. "The gospel at its profoundest point stands in utter contradiction to human wisdom," writes author Gordon D. Fee. "God has redeemed our fallen race by means of the ultimate contradiction in terms, a crucified Messiah."

"How great is the love the Father has lavished on us, that we should be called children of God" (1 John 3:1). We are neither common nor miniscule intrusions upon his time and energy to be flicked away. He gave all that he was and possessed in order to restore his fallen creatures to a place of honor and fellowship with him. What great mystery. What uncommon love.

The God Who is There

Thousands of families take to the mountains or the ocean when summer vacation rolls around. Some even leave their air-conditioned homes, pitch a tent in some specially chosen spot and live there for a period of time. That is, they will if they're very brave.

> *"The Word became flesh and made his dwelling among us."*
> John 1:1

Nothing can quite test the endurance of a family like living together in a tent. Whether a two-room deluxe style or the one-person pup variety, camping means together. Together in close proximity with the annoying habits of spouses and children in your face.

You're together—cooking, eating, sleeping. You can't run to your basement hide-a-way and shut the door. You can't bury yourselves in the television screen to escape the inexorable inevitability of talking to each other. You'll need to interact just to survive the camping experience.

A sudden thunderstorm threatens just as you unfold the tent and lay it out flat on the ground. You pour over the enig-

matic symbols that sort out the short poles from the long poles. All the while the kids insist they're dying of hunger. Mom discovers that Dad must have slept through the entire Boy Scout program. As for Mom, she's been sweeter.

Frustrations mount. Rumbles of discontent muffle the chirping of crickets and expose your vulnerabilities like unprotected skin in a patch of poison ivy. Miscommunications fire through the campsite with the suddenness of lightning. No one dares to ask, "Are we having fun yet?"

With patience, compromise, and undiluted doses of love, the fun may come. There will be those delights of nature you left home for, those warm, fuzzy experiences that delight your heart. There may even be some unimaginable insight that explodes in the soul and changes who you are forever. But make no mistake; it will cost you something.

God promised Moses that he would pitch his tent and dwell in the midst of his people. It is a central theme throughout Scripture. From Exodus to Revelation we find the imagery: a holy God "pitching his tent" among his people. In the familiar passage in John 1, "The Word became flesh, and made his dwelling among us," the Greek word for "dwelling" literally means to "pitch a tent."

Talk about leaving the air-conditioned order and serenity of suburban living! God left the perfection and unimaginable beauty of heaven where legions of angels sang his praises, to pitch a tent among unholy people who find fault with his every move.

Describing his apocalyptic vision of the new heaven and new earth, John writes, "The tabernacle of God is with men, and he will dwell with them, and they shall be his people. God himself will be with them and be their God" (Rev. 21:3 NKJV).

The literal interpretation once again is "to pitch a tent."

He is, in Francis Schaeffer's words, the *God who is there.* He is personal and among us in a way that is extraordinarily reassuring but disturbing in the extreme. We cannot avoid him or revoke his claims upon us.

David asked, "Where can I go from Your Spirit? Or where can I flee from Your presence? If I ascend into heaven, You are there; If I make my bed in hell, behold, You are there" (Ps. 139:7-8 NKJV). He is the God who is there, and he demands that we respond.

He demands a response first of all because he loves us and knows that unless we interact with him we will not survive this expedition. He demands that we acknowledge him because doing so will result in joy beyond our wildest imagining. He knows that only his life in us can bring purpose, peace and fullness to our days.

To bring us to the highest and best our souls can become he pitched his tent among us. Dorothy Sayers has written, "For whatever reason God chose to make man as he is—limited and suffering and subject to sorrows and death—he had the honesty and courage to take his own medicine." She reminds us that he has himself gone through the whole of human experience, from the "trivial irritations of family life and the cramping restrictions of hard work and lack of money to the worst horrors of pain and humiliation, defeat, despair and death."

Our Lord took the abuse we hurled at him all the way to the Cross, and still he stays. Yes, when he pitched his tent among us, he was in for the long haul. We can be sure that he has come to stay, even as Scripture reminds us: "Surely I am with you always, to the very end of the age" (Matt. 28:20).

Heaven's Bread

Jesus used the occasion of the feeding of the 5,000 both to demonstrate his authority over creation, indeed over life itself, and to teach the most vital object lesson about himself. When an astonished crowd experienced the miracle they wanted to make him king.

> *"I am the bread of life. He who comes to me will never go hungry, and he who believes in me will never be thirsty."*
> John 6:35

Material concerns were at the forefront then just as they are today. Imagine having a king who could make a meal sufficient for 5,000 men, plus women and children, from one little boy's lunch! They pursued him, anxious for another miracle and for the satisfaction of their material hungers.

Alone with his group of disciples, Jesus explained the larger miracle. "I am the bread come down from Heaven," he said, and spoke of the necessity of eating his body and drinking his blood. He must have known how bizarre these words sounded. "Does this offend you?" he asked (John 6:61). But he was speak-

ing of his death that would result in eternal life for all who believe in him and accept his sacrifice for their sins.

Jesus had told the disciples after the feeding of the 5,000 to gather the pieces left over. "Let nothing be wasted." What did Jesus and the disciples do with the leftovers? Did they take them along for sustenance on their further travels? Did they distribute them to the poor?

Caring for resources was a general principle with Jesus. He would not waste resources—his own or ours. Not even the smallest crumb of the little boy's lunch was wasted. Nothing we give to Jesus ever is. Even our tears, Scripture says, are "stored in his bottle" (Ps. 56:8). Those things we regard as negative or useless, Jesus turns into nourishment. The poet William Cowper reminded us of this when he wrote, "Fear not, the clouds you so much dread/ are big with mercy and will break/ in blessing on your head."

"And this is the will of him who sent me, that I shall lose none of all that he has given me, but raise them up at the last day" (v. 39). Never mind what will happen to 12 baskets of fish and bread. Realize that God has sent the Bread of life that no one need be lost. Mankind is God's most precious resource and he has made provision for every one to be part of himself and to live eternally with him.

"For my Father's will is that everyone who looks to the Son and believes in him shall have eternal life, and I will raise him up at the last day" (v. 40). Here is the meaning of the miracle. The Bread of heaven, Jesus himself, has been blessed and broken for us that we may be partakers of the divine life of God.

Those disciples who followed him after the miracle listened to his difficult words and began to break away from him.

. .

"The ones who feed on me will live because of me," Jesus said. "The Spirit gives life; the flesh counts for nothing ... The words I have spoken to you are spirit and they are life" (v. 57, 63). The people walked away, disappointed that there would be no more bread and fish for their bellies, no more miracles. And Jesus was greatly saddened. He turned to his trusted Twelve and asked if they too were thinking of leaving him.

"Lord, to whom shall we go?" Simon Peter responded. "You have the words of eternal life" (v. 68). And he affirmed their faith in Christ as the "holy one of God." But Jesus, knowing their hearts, said the saddest words of all. "Have I not chosen you, the Twelve? Yet one of you is a devil!" He was not referring to Satan or his helpers but to Judas who would turn his back on him and despise his gift of love. One of those he had chosen would be lost.

God has chosen every one of us to receive the gift of himself. Yet there are those who will not believe, who will refuse to put their trust in him. While the Bread of Life is held out in loving hands, they will sell their birthright for meager crumbs of this world's bread. This is the greatest tragedy in life.

The world would feed on you, drain your resources, then discard you. Jesus offers you the chance to become part of himself—the Bread that satisfies eternally. He offers words of spirit and life. May none of us walk away blinded by the glitz of worldly food but eat and drink the life-sustaining nourishment of Jesus' life in us.

Carried Between His Shoulders

Many are the Scriptural parallels between the shepherd's care for the sheep and God's loving attention to his children. But perhaps none is quite so engaging as the picture from Deuteronomy.

A shepherd coming down from the hills with a sheep that had wandered away was a characteristic pose in Jesus' day. Often the animal would be bleeding or sick as it lay wrapped around the shepherd's neck and nestled between his shoulders.

*"Let the beloved of the L*ORD* rest secure in him, for he shields him all day long, and the one the L*ORD* loves rests between his shoulders."*
Deut. 33:12

The sheep, whether lost through its own stupidity or because of some natural or unnatural factor beyond the animal's control, was the object of the shepherd's concern. Not con-

tent to have the majority of sheep at home safe and well, the good shepherd risks his life to restore that one lost sheep.

"And when he finds it, he joyfully puts it on his shoulders and goes home" (Luke 15:5-6). When a lost soul is restored to God, there is great joy in heaven. It is intriguing to imagine God whistling with delight, perhaps laughing from the fullness of his great heart.

The phrase "between his shoulders" is more tender and meaningful than perhaps "over his shoulder," for we are reminded that what lies between the shoulders is the heart. And that is where God holds us—in the most intimate of positions—in his very heart. God has chosen to set his love upon lost people, to reclaim them and make them his friends.

Mark Twain wrote: "The proper office of a friend is to side with you when you are wrong. Nearly anyone will side with you when you're right." God as our truest of all friends loves us in spite of our sin and longs to restore us to the place of fellowship. "God demonstrates his own love for us in this: While we were still sinners, Christ died for us" (Rom. 5:8). He chose to "side with us," to befriend us, and to do for us what we could not possibly do for ourselves.

The newborn baby is most comforted when lying on mother's breast hearing the warm beating of her heart sensed from the beginning. The child knows that unique rhythm as well as one can know the voice of another, and is at home.

"Carried between the shoulders" implies not only a place of love and intimacy, but also a position of honor. The sheep was not dragged along behind or tossed into a bag to be toted, but placed high on the shepherd's shoulders where it could share the same view, breathe the same delightful air, hear the soothing voice of its master.

Jesus says to those who follow him: "I no longer call you servants, because a servant does not know his master's business. Instead, I have called you friends, for everything that I learned from my Father I have made known to you" (John 15:15).

A position of love, of honor, and also, of protection. The sheep perched high between the shepherd's shoulders would be safe from creatures that would devour it, from pitfalls that could break its leg, from a hundred menacing elements in its environment.

Evil would snatch away those upon whom God has set his love, would turn them from their position of love and honor, and would destroy them. Jesus promised the Christian that he will always be with him and will keep all that is committed to him. Whatever ills may befall us in this world, we have the knowledge that our ultimate safety, our rest, is assured. The hymn reminds us:

> *There is a place of quiet rest,*
> *Near to the heart of God.*
> *A place where sin cannot molest,*
> *Near to the heart of God.*

There is no one beyond the love and protection of God. No matter how far we may have strayed from his righteous demands, he is willing to restore and nourish us. He has honored every person by setting forth his own image upon their lives, and then reclaiming what sin had spoiled. A contemporary song affirms God's tender love for every person and reminds us that God is strong enough and willing enough to carry us through this world and into the next.

"If he carried the weight of the world upon his shoulders, I know, my brother, that he will carry you."

God's Shadow

What is more intriguing, more alluring and frightening than shadows? As children we hid from them, played with them, created them, fascinated by how the adroit placing of a finger or two against a light backdrop could become a prancing deer, a rabbit or a monster. Most of all, we were intrigued by our own shadows which were sometimes amazingly tall and strangely disproportionate.

> *"He who dwells in the shelter of the Most High will rest in the shadow of the Almighty."*
>
> Ps. 91:1

We also found shadows to be of great comfort. After the wearying heat of an afternoon we often sought the shadow of an overspreading tree—or even of a great rock. There the serenity, the sureness, would return and we were re-energized.

In literature, shadow as a universal symbol has always been related to evil or darkness or the unknown. Yet in Scripture the word "shadow" often has the rarer meaning of a shelter. The word can also mean an inseparable companion, follower,

or shade within defined bounds. Could all these ideas be involved in the imagery of God's shadow?

Along a narrow, winding path suited only for single file a little girl walked behind her daddy through the dusk of early evening. Father and child carried home their parcels from a day's shopping trip in town.

"I'm afraid," whispered the child. "I wish I could hold your hand, but there's no room on this narrow path."

"Just walk in my shadow, child, and you will be safe—all the way home," said her father. The little girl followed in her father's shadow and was comforted and secure.

Everyone knows that in order for a shadow to be present there must be both light and darkness. So if God is light and "in him is no darkness at all" how is it that he casts a shadow? Shadow as an indicator of light reveals that somehow light has confronted darkness. God's shadow was cast as he, the light, confronted sin, the darkness. Without the emergence of light—"the true light that gives light to every man" (John 1:9)—this world would indeed be a cheerless place, a place too dark for shadows. In Christ we see "the exact representation of God's being, sustaining all things by his powerful word" (Heb. 1:3).

What kind of shadow does God cast? Is it an unreal thing, a thing without substance? The picture we're considering intimates that his shadow is a secure place, a place of protection from the scorching dangers of life. Rather than fearing his shadow, we are comforted because we recognize that he is himself light confronting our darkness. When we place ourselves in his shadow we are standing on the most solid plane of all. For we know that heaven and earth will pass away, but Christ (the rock, the express image of God, the

eternal one) will remain forever the same.

Although the shadow of the Almighty is indeed a secure place, it is not a place of ease or banality. God's shadow includes a Cross. If we would live with him, we must also suffer with him. That is part of what it means to know Christ—to share in his sufferings. The hymn writer, Elizabeth Cecilia Clephane, put it this way in her well-loved hymn:

> *Beneath the cross of Jesus*
> *I fain would take my stand.*
> *The shadow of a mighty rock*
> *Within a weary land.*
> *A home within the wilderness,*
> *A rest upon the way,*
> *From the burning of the noontide heat*
> *And the burden of the day.*

Security and suffering are both represented in the image of the shadow of the Almighty. While God's shadow included a Cross, it culminated in Glory. Knowing and resting in Christ also means sharing in his glory. In Philippians 3:10, Paul expressed his yearning to know Christ, both the fellowship of suffering with him and the power of his resurrection. Those who rest in the shadow of the Almighty share now in the resurrection of the spirit which occurred when we confessed our sins and became new creatures in Christ. But one day we will also know the power of his bodily resurrection.

What a dwelling place—full of the sense of deep security, of friendship that makes suffering sweet, of holy unity that satisfies the longing of soul, mind and body. While we now "see through a glass darkly," perhaps aware only of impressions, of glimpses of who he is, of a divine shadow, one day we shall see him as he is. Until then we walk in his shadow,

safe, not because we are shielded from dangers and sufferings but safe because his presence makes us victorious in every situation presented in this world and keeps us all the way home.

On Eagles' Wings

Since ancient times the eagle has been regarded as the emblem of might and courage. Its great power of vision, the wild grandeur of its habitat, the vast heights attained as it soars across the sky, combine to enlist the admiration of us all. The eagle has captured the imagination of poets like Alfred Lord Tennyson, who penned these well-known lines:

> *"But those who hope in the LORD will renew their strength. They will soar on wings like eagles; they will run and not grow weary, they will walk and not be faint."*
> Isa. 40:31

> *He clasps the crag with crooked hands;*
> *Close to the sun in lonely lands*
> *Ringed with the azure world, he stands.*
> *The wrinkled sea beneath him crawls;*
> *He watches from his mountain walls,*
> *And like a thunderbolt he falls.*

Isaiah's simile of renewal is remarkable for a number of important reasons. The eagle is capable of great aerial feats,

but it cannot soar by its own strength. It is dependent upon the jet stream to bear it aloft. Its natural capacity to fly is maximized by the power which lifts and impels it.

The Holy Spirit is the great Wind who bears the Christian up on wings of love and healing and makes possible heroic flight. We have no power of our own to do this; we must depend on God. As the eagle cannot force the wind to bear it in a certain direction, so the Christian cannot dictate which way the winds will blow. He can only cooperate with the Holy Spirit. In doing so he discovers his greatest potential.

Gaston Foote records an anecdote about two young boys who removed eggs from an eagle's nest they had found while climbing. They put the eggs under a hen in the barnyard. Eventually the young eagles hatched. The mother hen cared for the eagles as though they were her own. One day a great eagle swooped down over the barnyard. Feeling kinship to the great eagle, the fledglings tried their wings. Day after day the great eagle came. Day after day the young eagles tried their wings. Then one day the young eagles flew high in the air and followed the great eagle into the limitless sky, their native atmosphere.

Man was made for God. In spite of our fallen condition, something within us calls us to a higher experience. It's as though we hear a whisper of Eden and come, as William Wordsworth put it, "trailing clouds of Glory." We were intended to dwell in the heights, our native atmosphere. If we choose God's dwelling, we will find ourselves soaring, borne on the wings of God.

Paul gave this rule for holy living to the Christians in Colosse: "Since, then, you have been raised with Christ, set your hearts on things above, where Christ is seated at the right

hand of God. Set your minds on things above, not on earthly things" (Col. 3:2). When we do this, we are expressing the very fact that our hope is in God. Isaiah wrote, "Those who hope in the Lord will ... soar on wings as eagles."

Let no one imagine that such a life of faith as Paul describes, the kind of life Jesus offers, is an easy, safe way. To walk when we cannot see our way, to run when the path is rugged and strewn with hazards, to soar on wings like eagles, dependent upon the current of the Spirit's wind, will require faith of the deepest kind.

"Agnostics often think that people run to God because they are afraid of dying," Annie Dillard has observed. "On the contrary, the biblical religion is not a safe thing. People in the Bible understood the transitory nature—the risk—of life better than most." She concludes that those people did not use religion as an escape hatch. "Faith forces you to a constant awareness of final things. Agnostics don't remember all the time that they're going to die. But Christians do remember."

We remember. "We live by faith, not by sight. We are confident ... we make it our goal to please him" (2 Cor. 5:7-9). What pleases God is that we should reign with him in glory as sons and daughters of light. So we put our hope in him and "soar on wings as eagles."

Let Me Count the Whys

Couples in love live in a kind of altered state in which everything is eclipsed with wonder. They become suddenly aware of meadowlarks and anemones, of wind moving in the trees like music and the heady romance of summer bees.

> *"I led them with cords of human kindness, with ties of love; I lifted the yoke from their neck and bent down to feed them."*
>
> Hos. 11:4

The office secretary with her sensible shoes develops a peculiar desire to dance to work and wear daisies in her hair. The dusty CEO with yesterday's spinach in his teeth takes on a sort of charm. Men who have never liked poetry find themselves writing it. Some who had previously thought Browning's lines melodramatic catch themselves quoting, "How do I love thee? Let me count the ways."

People in love are content to gaze into each other's eyes, seeing something continually new and exciting in those depths. They say "I love you" more times than they ever recited their multiplication tables. And when those magic words are whispered, one often gazes back with absolute wonder and asks the other "why?"

Sometimes they ask "why" because they want to hear their loved one recite their catalogue of virtues with adoring phrases. But most often, they simply can't believe such a poignant, tender experience could be theirs, that someone so wonderful could find sufficient reason to give their love.

From the first passion to the mature bonding, the mystery of human love will always engage us. It is, however, but a dim picture of the great love of God. When we first embrace the truth that God is not only our creator and governor but also one who cares about us supremely, it is as baffling an experience as falling in love. But it has eternal significance for us all.

The psalm writer's wonder drove him to poetry. He asked, "When I consider your heavens ... the moon and stars, which you have set in place, what is man that you are mindful of him, the son of man that you care for him?" (Ps. 8:3-4).

God's love is so powerful that he was willing to live among us, to suffer all the indignities of humankind, and to conquer our worst enemy, death. C.S. Lewis suggests that the incarnation of Jesus Christ might be something akin to man becoming a slug. What kind of love would cause someone to make such an exchange of stature and glory?

Hosea's beautiful picture describes God's love as a wooing, a drawing with "gentle cords." Not a jealous passion that subjugates, but a love that stoops to nourish and enrich. In-

deed, he stooped all the way from the magnificence of Heaven to feed us with eternal life.

It is love that bids us come by faith and receive him. He has "loved … with an everlasting love" (Jer. 31:3). When we accept his profound but simple declaration and give ours in return, we enter not into an altered consciousness, but into the divine fellowship God longs to provide for the people of his love.

It is a love that deepens and binds us ever closer to him. It will be costly to follow him, for love is always costly. But nothing can compare with the presence of him who is himself light and love and truth. As someone has said, "It is better to walk in the dark with him than in the light without him."

We cannot listen to an ardent declaration of esteem and make no answer. To do so would be the worst expression of disdain. For love's opposite is not hate but neglect. God's love demands a response. Someone has written, "What are my lame praises compared with your love? Nothing and less than nothing, but love will stammer rather than be silent."

At what peril do we turn aside from God's love and suggest it doesn't matter. Even when we do not recognize him, God continues daily to pour out love upon us. But Scripture warns that one day he will wrap up this world, taking with him those who choose to be with him.

It will be our choice, not his. For he has already chosen. "I have set my love upon him," God said. In so many ways he has declared his love. "But God demonstrates his own love toward us, in that while we were still sinners, Christ died for us" (Rom. 5:8).

We will always with wonder count the whys, but let us by

faith accept his way. Let us be drawn by those gentle cords and respond with our own devotion. Let us be fed by his nail-scarred hand.

Like a Mother

I remember as a little girl being terrified of the cracks and miscellaneous flaws in the ceiling and walls of my bedroom. Unable to fall asleep, I stared at these things in the half-light that filtered through the window. The longer I stared the more convinced I became that the flaws were unknown creatures of various sizes and shapes that would do terrible things to me in the night.

"You will nurse and be carried on her arm and dandled on her knees. As a mother comforts her child, so will I comfort you."
Isa. 66:12-13

I screamed for my mother, who always came, though she had often before explained what the "creatures" really were. She would sit beside me, taking my hand or caressing my forehead until I grew comforted and sleepy.

God is frequently pictured as a loving father in Scripture, but he is also compared to a mother. The noblest characteristics of father and mother are resident in his heart—both the strong, protective love of the man, and the patient, comfort-

ing love of the woman. The first stanza of John Oxenham's poem beautifully depicts this synthesis:

> *Father and Mother, thou,*
> *In thy full being are—*
> *Justice with mercy intertwined,*
> *Judgment exact with love combined,*
> *Neither complete apart.*

"A mother is not only a child's first lover, but a name for God in the lips and hearts of little children," said W.M. Thackeray. A Jewish proverb says, "God could not be everywhere, and so he made mothers." A Persian proverb teaches, "Heaven is at the feet of mothers." The sacrificial quality of mother-love has been eulogized from earliest times, and the Bible is replete with models of mothers who exemplify the best and dearest virtue of sacrificial love.

Jochabed, desperate to save the life of Moses from the unscrupulous Pharaoh, contrived a dangerous but clever plan to hide him in the river with the watchful Miriam near at hand. So carefully had Jochabed laid her plans and trained her daughter that even the winds of chance could not dash her cleverly calculated maneuvers. So it was that when Pharaoh's daughter found Moses, Miriam eagerly offered the services of a Hebrew nurse—the child's own mother. No plan was too risky to keep Jochabed from saving this child of her love.

No plan—even the death of his only Son—could keep God from saving the children of his love. In the gift of Jesus Christ we see the sacrificial mother-love of the Father. And in the gentle wooings of the Holy Spirit, we see the inexplicable comfort that has embraced suffering servants of God since the beginning of the ages. He makes himself known in ways both mysterious and beautiful to the soul seeking solace.

E. Stanley Jones tells the story of a badly wounded soldier who was unconscious, close to death. Hospital officials sent word to the mother waiting outside that nothing more could be done for her son. Even the slightest excitement might bring about his death.

She begged to sit near him, promising not to speak or make even the slightest noise in the room. With bursting heart she waited beside his bed, placing her hand gently on her unconscious boy's forehead. Without opening his eyes, the boy whispered, "Mother, you have come." He knew his mother's touch.

The imaginative terrors of my childhood have long since been replaced by adult fears. Mother is no longer there to comfort me, to keep me company until I sleep. But in touches tender as a mother's God makes himself known in the deepest night.

"Praise be to the God and Father of our Lord Jesus Christ, the Father of compassion and the God of all comfort" (2 Cor. 1:3). When Christ puts his hand on the fevered brow of our souls, we know the meaning of that touch, we know he has come.

Without Flaw

What can be described as perfect? Pure, without flaw? Snow? No, we're told that a microscope would reveal thousands of tiny impurities. A crystal clear mountain stream? Unfortunately, that too is only relatively pure. Is there anything without flaw? A blank screen flickers in the mind, reminding us that, of all things, human beings are most flawed.

> *"The words of the Lord are flawless, like silver refined in a furnace of clay, purified seven times."*
> Ps. 12:6

I used to think that the pitcher presented to me by my grandmother was pure silver. The first acquisition for my hope chest—or "despair barrel," as chances for marriage were sometimes described. The sterling container, designed by a master craftsman, had an exquisite shape and delicate *fleur de lis* etching. It sparkled with a thousand lights; the clarity of the silver dazzled the eye. But the silver wasn't really pure. It contained a mix of copper and other metals. And however brightly it glowed when polished, it soon grew

dull and dark with the effects of oxygen.

Another picture from childhood emerges. Sister Mary Elizabeth, rosary beads swaying on her left hip, served a rectory in our Chicago neighborhood and met every passerby with loving interest. A cherubic quality shone in her face ringed by the starched white collar of her severe black habit. Without make-up and unobscured by the least tendril of hair, her face seemed to me angelic, pure.

But the image begins to tarnish in my own adult awareness. She, like all of us, is undeniably flawed.

As for words, they are flawed by misunderstanding, misuse and abuse. Ever changing and developing, language is anything but pure. Perfectly good words that served generations in the past have come into question—like the word "gay," a rhymer's dream, which meant "bright, happy, cheerful."

Then there are words which vary in meaning depending on locale. I was once told while visiting in London to lock the boot and open the bonnet. I was wearing neither of these articles and wouldn't have known what was implied by locking and opening them. I was surprised to discover the speaker was referring to the trunk and hood of my car.

Words fail us, and we fail them—intellectually and morally. Sometimes our words are found false upon later scrutiny or discovery. Men of science who once propounded the theory that the world was flat truly believed their words were good and true.

We can also use language to satisfy our own needs and desires, quite apart from considerations of truth or rightness. James wrote that "the tongue also is a fire, a world of evil among the parts of the body ... a restless evil, full of deadly poison" (2:6, 8). In contrast, "the words of the LORD are flawless, like

silver refined in a furnace of clay, purified seven times" (Ps. 12:6).

Because silver is easily reduced to pure metal from its ores by relatively low heat, and because it is occasionally found free in nature, it probably became the third metal (after gold and copper) that ancient civilizations learned to use. It was well known earlier than 4000 B.C. In the psalmist's day, it was the chief metal used in coins.

For all its value and beauty, and even though it is refined seven times, silver fails as a metaphor for perfection. The psalmist's words fall on our ears with a strangeness, a singularity, for nothing is flawless. Perfect. True. All of nature is fallen. Nothing, no one but God himself is without flaw. Not only are his words flawless; they are everlasting. "The grass withers and the flowers fall, but the word of our God stands forever" (Isa. 40:8).

It is the one Truth in all of our knowledge and experience that we can count on. No matter what subsequent truths are discovered, what revolutions occur in science or any other pursuit, the indelible Word of our God remains flawless and unchanged.

How finely tuned our ears should be as we bend to catch his whisper. How diligently we should apply our hearts to the written Word of Scripture. With what intensity and joy should we study his revealed "Word made flesh"—Jesus Christ whose righteousness can repair the terrible damage of sin and make us pure.

A Lady Named Wisdom

The writer of this proverb has used the extended metaphor of a gracious woman whose intelligence and skill have brought her to a place of high standing and influence, and whose generosity and hospitality are renowned. Seven pillars are said to support her house. Seven is sometimes called "God's number" or the number of perfection.

> *"Wisdom has built her house; she has hewn out its seven pillars ... She calls from the highest point of the city ... 'Leave your simple ways and you will live; walk in the way of understanding'."*
>
> Prov. 9:1, 3, 6

James, in his epistle, also uses the metaphor in his comparison of two kinds of wisdom. He speaks of wisdom that is true, that comes from God, describing it as "pure ... peace-loving, considerate, submissive, full of mercy and good fruit, impartial and sincere" (3:17).

As a woman who prepares a dinner and invites all who will come to her, so wisdom invites all who would walk in her

ways to come and learn. James contrasts this "heavenly wisdom" with another kind of wisdom that is "earthly, unspiritual, of the devil." Such wisdom is born of bitter envy and selfish ambition and will result, says James, "in disorder and every evil practice."

When I was just out of high school and working part time at the Central territorial headquarters of The Salvation Army in Chicago, many interesting duties fell to me in the editorial department of which I was a part. Mostly I typed manuscripts, preparing them for *The War Cry,* and transcribed letters from my shorthand notes. The work was fascinating and invaluable as a learning experience in the fields of writing and publishing.

Perhaps of most value though was my association with a woman who exemplified the symbolic woman described in the Proverb. Mrs. Commissioner John McMillan (R) was at that time responsible for material in "The Woman's Page." But by this time she was growing quite feeble and was not always able to walk over from her apartment in the Evangeline Residence to bring her notes into the office. It fell to me to go to her home and decipher her increasingly difficult-to-read handwriting.

Mrs. McMillan impressed folks as a no-nonsense woman with a somewhat austere presence, which made the prospect of working for her a formidable challenge. Her reputation as a great lady was in itself intimidating. Further, she demanded perfection. The slightest error in the copy brought a frown to those penetrating eyes and an edge to her voice. "Nothing is merely good enough," she would say. And you knew you were being admonished.

When I overcame my initial fear, I found a woman of astounding sensitivity and intelligence, with a wit and humor

that delighted me. Spellbound, I listened to tales of adventure in the great Salvation Army in which she had served for more than 50 years. She had lived a life of faith, moving out on the directive of God even when the odds were against her. She lived a life of service rather than searching for pleasure or wealth. She understood the human condition and the hopes and dreams of people. Where had she learned such wisdom?

"Who is wise and understanding among you?" asks James. "Let him show it by his good life, by deeds done in the humility that comes from wisdom" (3:13).

Why is it we're more fascinated by an enigmatic personality with deep-set eyes who tells us something obscure about our past or future than by someone who can tell us how to find the true path of wisdom for this life? James has put the emphasis where it belongs. The truly wise person will be the person who lives a life marked by goodness and humility.

God is our only source, for we can't be good on our own. No matter how remarkable our character, we will always fall short of God's standard for wisdom. We must ask him. "If any of you lack wisdom, he should ask God, who gives generously to all without finding fault, and it will be given to him" (James 1:5).

Door of Hope

What is it about a screen door on a sum-mer's day that is so attractive, especially to children? In and out they go, shattering the peace of the neighborhood. "Don't slam the—!" My mother never could get the entire warning out before there came a slap of wood against wood, a thud and whir of the coiled spring resettling against the door.

"There I will give her back her vineyards and will make the valley of Achor a door of hope."
Hos. 2:15

Were we mentally challenged that we couldn't remember to bring everything we needed out with us at one time? Could we not make up our minds whether we wanted to be in or out? Were we simply absorbed in our play or did we enjoy exasperating our mothers?

I've ruminated about this interesting bit of trivia since watching my own grandchildren. I too have caught myself in midsentence with "Don't slam the door!" Perhaps the sight of an open door has a peculiar appeal for all of us.

A door signals welcome, freedom and a sense of belonging. As a child, I remember ducking inside in the midst of my play just to make sure Mom was still there, that she was available to me if I needed her.

An open door is above all a symbol of hope. It's a symbol the Scriptures employ frequently and often in connection with hope. Hosea's marriage could definitely be viewed as beyond hope. His wife Gomer deserted him and their children and became a harlot, selling her body and soul to the cult of Baal. In the midst of this family trauma, God said he would make the Valley of Achor a door of hope.

"Achor," meaning "trouble," was so named for the sin of Achan, whose disobedience resulted in Israel's disastrous defeat at Ai. While leading the Israelites through the Promised Land, Joshua discovered forbidden spoils of war—gold and silver—hidden in Achan's tent. The place where Joshua carried out God's judgment on Achan was declared "the valley of Achor."

We too live in a valley of trouble. We're threatened with defeat and disaster. The air is dank, and darkness broods around us. There seems no way out, only deeper trouble, but a door of hope has opened! It's just like God to give us hope even at the lowest points in our journey.

Hosea found hope for his desperate situation. His story becomes symbolic for all of us. This promise of hope was fulfilled by the one who said, "I am the door. If anyone enters by Me, he will be saved" (John 10:9 NKJV).

Often we find ourselves in despair because we have been disobedient. We have ignored the laws of God meant for our good. We deserve the just punishment of our deeds, for God's Word declares "the wages of sin is death" (Rom. 6:23).

Spiritual death is the ultimate valley, more to be feared than the physical cessation of life. God stepped into this hopeless situation and declared that there is a way out. He himself becomes the door through which we may pass from death into life.

The great, good news is that even though we might deserve the despair we're experiencing because we've disobeyed God, he doesn't leave us to lie in beds we have ourselves made. The Bible tells us that "while we were still sinners, Christ died for us" (Rom. 5:8). He never shuts the door, even when we've left him standing in the cold time after time. Like the loving Father he is, he stands ready to respond to our slightest inclination toward him. As pictured in the parable of the prodigal son, he comes running to meet us as soon as we turn toward him. Readily he draws us back into his intimate, loving circle.

Sometimes we find ourselves in the valley of trouble through sickness, loss, or sorrow common to all world travellers. As Job said, "Man ... is of few days and full of trouble" (Job 14:1). God, through Jesus Christ, is the door flung open to receive us.

Stumbling and crying with the pain of our journey, we find he is there to receive us. He waits to bind up our wounds, to refresh us with his loving Spirit, to cheer and encourage us. He gives us unbounded hope for our journey.

Our Lord provides hope not only for our journey through this world, which has been poetically described as a "vale of tears," but for eternity. "See," says Jesus, "I have placed before you an open door that no one can shut" (Rev. 3:8).

Children of Love

Adoption implies the conscious choice of bringing up someone else's biological child. It means taking that child to your heart and giving him all the rights and privileges of a child born into the family.

Many parents today are raising adopted children with tender understanding and uncompromising love. Lucky is the child chosen to become a part of someone who will love and provide for his needs, regardless of personal sacrifice.

> *"[God] predestined us to be adopted as his sons through Jesus Christ, in accordance with his pleasure and will—to the praise of his glorious grace, which he has freely given us in the one [Jesus] loves."*
> Eph. 1:5-6

In Paul's day, the picture of adoption was even more meaningful than it is today. Under Roman law a father had absolute power over his children. He could make his child work on his estate as a slave in chains. He even had the power to kill him if he wished. Even if the son were old enough to play an active

part in political affairs and to maintain a position of honor, Roman law gave the father absolute authority over his child for as long as they both lived.

Under Roman law, *patria potestas* declared that a child could not possess anything; and any inheritance or gift given him became the property of his father. Regardless of the age or prominence of the son, he was absolutely in his father's power.

Under such circumstances, adoption was a serious step. Though it was a drastic venture to take a child out of one *patria potestas* and put him into another, adoptions were common, sometimes done to ensure that a family would not become extinct.

William Barclay tells us that adoptions were carried out in symbolic sales. Twice the biological father sold his son and twice he symbolically bought him back; finally he sold him a third time, and at the third sale he did not buy him back.

After the "sale," the adopting father had to go to one of the magistrates and plead the case for the adoption. When the procedure was complete the person who had been adopted had all the rights of a legitimate son in his new family and completely lost all rights in his old family. In the eyes of the law he was a new person. All debts and obligations connected with his previous family were canceled.

The Apostle Paul uses the picture of adoption more than once to describe how God chooses people to become his sons and daughters through Jesus Christ. We were absolutely in the power of sin. God, through Jesus, took us out of that power into his power. That adoption cancels the past; we are made new. We have passed from the family of the world and of evil into the family of God.

We all know that "absolute power corrupts absolutely," with only one exception. God is the only one deserving of complete trust. To no earthly father would we want to invest absolute power over our lives. However good and upright, a man or woman is vulnerable to the winds of change, to the terrors that afflict human personality.

Only God loves us with a truly unselfish, unconditional love that defies even the most erudite explanation. "I have loved you with an everlasting love," God declares. "I have drawn you with loving-kindness" (Jer. 31:3). Those who place their faith in him need have no fear what might become of them. For God is good and just. He can be no other. He is God.

Such a father in whom to place our absolute trust for time and eternity! And what contrast to our former estate. Left in the hands of the "prince of the power of the air," we would be doomed to the whims and witchery of the father of lies.

To adopt us into his family cost God a great deal more than money or yards of legal red tape and frustration. With what agony he pleaded for us from Calvary, securing our place in the family of God with his own blood. To us is given the promise, "God will meet all your needs according to his glorious riches in Christ Jesus" (Phil. 4:19).

When the King Comes

In this figurative description of the last judgment, Jesus sits on the throne of His glory to judge the world. The righteous and wicked are as distinct as sheep and goats. His right hand is the hand of blessing. His left, the hand of rejection. When he comes to judge, he will openly assume his role as King.

"When the Son of Man comes in his glory ... he will separate the people one from another as a shepherd separates the sheep from the goats ... the sheep on his right and the goats on his left."
Matt. 25:31-33

One of my favorite classic stories is about the old cobbler who in the course of his daily prayers learns that he will receive a visit from the Lord Christ Himself. The cobbler, a saintly man who lived a good life, looked forward with great joy to the day when the Master he loved and served would come.

The cobbler was a poor man, but he wanted to entertain his special guest with the best hospitality he could manage.

Through sacrificing his meager rations, the cobbler was able to buy a loaf of bread made of the finest wheat. This he would serve to the Lord when he came. He wanted to provide a beautiful glowing fire for his guest too, so he went without heat in order to set aside an extra log of the sweetest pine, so that there would be fragrance as well as comforting warmth. But the cobbler felt that this was not enough. He wanted to give something really special—a gift fine and worthy of the Master.

Since he was a cobbler he decided to make the Lord a pair of shoes. Using the finest leather available in the village, and tanning it until it was smooth and soft, he crafted the shoes.

On the morning of the projected visit, the cobbler woke with great joy in his heart and began as usual his daily work. All through the long day he hummed as he worked, occasionally looking toward the door of his little shop, and thinking of the joy of seeing his Master. But soon long shadows gathered and night spilled in the window above his work bench. The cobbler was filled with disappointment, for the Lord had not come.

During the course of the day, however, he had received three guests. The first was an old man, so thin it seemed the cobbler could look through the fragile skin to the jutting bones underneath. The old man was shivering with cold, for he had no log to make a fire. Feeling great pity, the cobbler gave away the fine log he had been saving for the Master. I still have the bread and the fine shoes, he thought.

Then a little child who lived under the wooden bridge with his ailing mother came to the cobbler's shop, begging a bit of bread. Touched by the large eyes encased in shadowy sockets, he gave away the loaf of fine wheat bread that was to be supper for his special guest.

Still later, came a younger man who had walked a long way across jagged mountains with no shoes. His feet were bleeding and bruised, and he had yet a long way to walk. The cobbler couldn't bear to send him on his way with no shoes, so with trembling hands he gave away the fine shoes—the last of the presents he had prepared for the Lord.

As he knelt for his evening prayers, the old cobbler poured out his disappointment that the Lord had not come. Perhaps the Lord had been angry that he had given away all the presents prepared for him. But even as he prayed, he heard his Lord's voice full of kindness and warmth. "I did come to you—three times this very day. First, you gave me a fine log with which to warm myself, and then a loaf of fine wheat bread because I was hungry. Again, when my feet were bleeding and sore, and I had a long distance to walk, you put shoes of finely crafted leather upon my feet."

"Whatever you did for one of the least of these brothers of mine, you did for me" (Matt 25:40).

As representatives of the Lord to the lonely and sick and poor, we go also to him—to minister to him. In a sobering picture of the final judgment, the King will decide our reward based on whether we have served others in the name and spirit of Christ or not.

Section 2
· · · · · · · · · · ·

Redemption

What's in a Nail?

What can this strange expression mean—God has given "a nail in his holy place?" The word "nail" sparks the imagination and suggests a link with the most startling and revolutionary event in history, the death and resurrection of Jesus Christ.

> *"And now for a little space, grace hath been showed from the LORD our God, to leave us a remnant to escape, and to give us a nail in his holy place, that our God may lighten our eyes, and give us a little reviving in our bondage."*
>
> Ezra 9:8 KJV

The Ezra text has to do with that prophet's role in rebuilding the second temple. It was completed in 515 B.C., after a host of Jews captured by the Babylonian King Nebuchadnezzar were freed and returned from exile.

In spite of violent opposition, the Temple was built. But something was terribly wrong with the real temple—the hearts of the people where God wanted to dwell. The Israelites had not kept themselves separate as they had been instructed.

They had disobeyed God. They had made alliances, personal and civic, which led them into idolatry and into such evil practices as sacrificing their children on fiery altars to foreign gods.

But it was a time for national repentance, and Ezra was at the apex, intervening for the people with God. Tearing his clothes and pulling out hairs of his head and beard, Ezra led the people in seeking forgiveness and restoration. On behalf of the people he wept and prayed. Together they continued to mourn over the unfaithfulness of the nation and their own rebellion.

Their repentance would cost dearly. Wives and children who refused to turn from idolatry were sent away. God had given them yet another chance, provided a "nail in his holy place" or a way to regain their inheritance as his children and as part of his holy kingdom.

God's chosen people, like us, had a history of rebellion. God provided his grace as the way to rebuild a broken relationship. His people had continually turned from him. In fact, the history of his chosen people reads like an electrocardiogram gone wild. Rebellion and repentance, rebellion and repentance. Time and again they embraced senseless and wicked gods and killed the prophets sent to heal them, until at last they turned the "nail" against him and pounded it into the hands and feet of God himself.

Imagine the young Savior working at the carpenter bench among the various tools and accompaniments of his earthly trade. When he lifted a nail to drive it into wood, did he flinch as he envisioned his own death?

Our own personal history is similar to that of the Israelites. We were participants in the crucifixion of the Son of God just as they were. The one God provided as the consummate

expression of his grace was crucified—fixed to the cross by a building implement turned into an instrument of torture.

His tormentors thought they had put an end to the claims of God on their lives by nailing him to a cross. They sought to silence his authority over them, to place themselves in control of their lives. But death was not strong enough to hold Jesus from his loving purpose—the destruction of all that is contrary to love and the uniting of all people everywhere with himself.

"I am able to destroy the temple of God and rebuild it in three days," (Matt. 26:61) said Jesus. It was the claim for which he was branded a blasphemer. But he spoke of his body and of his resurrection. And on the fact of the resurrection, the Church would be established—a "more perfect tabernacle, not made with hands," whose builder is God (Heb. 9:11 KJV).

His death redeemed his chosen people, but it also secured our place in his holy kingdom. We can trust God's grace. He "has provided a nail in his holy place"—nails, in fact, that pierced the Savior's hands and feet, securing our redemption and restoring a broken relationship. We were meant to be part of his building, part of a temple not made with hands, holy and indestructible.

When we accept his sacrifice as payment for our sins, we find forgiveness, fellowship and the knowledge that we are part of that heavenly building whose engineer is God and whose kingdom will never end.

"And now for a little space grace hath been showed ... that our God may lighten our eyes and give us ... reviving in our bondage." This grace is offered to each one of us freely that we may live forever.

The Romance of the Stone

The concept of God as the "Rock of Israel" first appears in Genesis 49:24 and emerges again in the Psalms. Isaiah goes beyond the imagery of the rock as a place of refuge and strength. He expands the image (8:14-15) to suggest that a "precious cornerstone" would be cut out of a mountain. "He will be a sanctuary, but for both houses of Israel he will be a stone that causes men to stumble and a rock that makes them fall." Daniel speaks of a "mysterious stone" (2:34, 35). A fortress for those who love God, this stone will become "a rock of offense" (Isa. 8:14 KJV) for those who oppose him.

"See, I lay in Zion a stone that causes men to stumble and a rock that makes them fall, and the one who trusts in him will never be put to shame."

Rom. 9:33

In the New Testament, we find that Jesus connects these

. .

images with himself. "The stone the builders rejected has become the capstone; the Lord has done this, and it is marvelous in our eyes" (Matt. 21:42).

Like a great romance, this Stone, rejected by many, has become the chief of all stones. And eternity will depend on what we do about this one—Jesus Christ.

Some regard friendship with God as something they can achieve themselves. By trying to follow the Ten Commandments or through tedious self-sacrifice, they attempt to be acceptable to him. But man's imperfection can never satisfy God's perfection. Sin must be dealt with and no amount of striving will bring about forgiveness. That is why God sent his Son. Without acceptance of Jesus Christ, we will never be able to please God. If we do not submit to his righteous plan, we will find Christ the Messiah a stumbling stone and a rock of offense.

The cross offended the Jews in Jesus' day because it summoned them to begin their religious life from the very beginning, at the foot of the Crucified One. They were in debt to him. Nothing they could do would ever repay the debt.

For many, Christ and the necessity of faith in him is still a stumbling stone. In pride, they prefer to do something to show their worthiness. But there is nothing we can do to make ourselves right with God. "All our righteous acts are like filthy rags" (Isa. 64:6). We cannot save ourselves.

"Jesus was sent into the world to be the Savior of men. But he is also the touchstone by which all men are judged," writes William Barclay. "If a man's heart goes out in love and submission to Jesus, Jesus is for him salvation. If a person's heart is unmoved or rebellious, Jesus is for him condemnation."

God's plan involves the greatest romance ever written—

the romance of the precious Stone begotten of God and cast in the setting of a sinful world that he might shine in our hearts. It is his will that we "are being built into a spiritual house ... acceptable to God" (1 Pet. 2:5).

Elizabeth Barrett's announcement of her coming marriage to Robert Browning brought strong disapproval from the British poet's parents. They in fact disowned her. Elizabeth wrote weekly letters to her parents, declaring her love, her longing to be reconciled to them. But she received no reply.

Ten years passed, and one day Elizabeth received a large box containing all the letters she had written to her parents. Heartbroken, she realized that none of them had been opened. Those letters, containing some of the loveliest and most eloquent expressions in English literature, had gone unread. By their rejection, her parents continued their estrangement from this beautiful, gentle girl who loved them deeply. They were never reconciled. How tragic. How unnecessary.

Pride and rebellion keep many of us from ever knowing the tenderness of the love of God and the power of his life within us. We continue to stumble over the stone which God meant to become the capstone—the vital foundation of joyful and meaningful life.

Of Sparrows and Sanctity

Purple petunias in a hanging planter on the front porch stir something in the soul that even cultured roses can't stimulate. Petunias say something of solid earth sense, of country wholesomeness and abundance.

Captured by a particularly beautiful plant at the local nursery, I compromised my budget and brought it home. With pride and loving attention, I watered it every evening and inspected for encroaching insects or fungi. Daily it flourished, proffering large, purple blooms with a commanding fragrance.

One evening I noticed a spray of blossoms broken off and

> *"Are not two sparrows sold for a penny? Yet not one of them will fall to the ground apart from the will of your Father ... So don't be afraid; you are worth more than many sparrows."*
> Matt. 10:29

hanging at a strange angle. Something like straw stuck out above the soil level. On closer inspection, the soil had been rifled—virtually hollowed out in the center and a light covering of straw placed over it. Some commandeering bird had instituted squatters' rights and taken over my petunia plant.

The nest with four tiny, mottled eggs of no particular color was firmly installed. Surely one couldn't evict the little sparrow who fretted and twitted whenever the planter was taken down to water around her nest. As the time drew nearer for the eggs to hatch, it was hard to find a time when mother sparrow was out of the nest in order to water around the edge of the planter.

Then one day as I prepared to water the thinning, yellowing flowers, I found a mass of throbbing membrane coiled where the eggs had been. The hairless bodies of four baby birds were without definition, but they were alive! A sense of awe that felt very like fear came over me. I quickly rehung the pot, afraid my touch might cause the mother to abandon these nestlings.

Now I watch with fascination as mother sparrow comes and goes with bits of things in her bill with which to nourish her young. I marvel at this deep caring that fills me. As quickly comes the awareness that God's human creatures are dying through neglect and abuse, not only on the other side of some distant shore but in our own quiet, suburban neighborhoods.

Do we become callous to the preciousness of life, the holiness of it? Have we tired of reading the newspaper accounts, of hearing the nightly litanies of yet another child wounded or killed, an old person dying alone in an obscure room? Does their suffering fail to move us because they are faceless and

distant and we can do nothing about their pain? Or nothing we've heart enough for?

The once-fragrant, purple petunias are dying. That's sad because they were once so beautiful, so vivid, so—alive! And yet, something pleads for this higher form of life—this higher form that is only four little sparrows too weak to lift their heads. Oh, God, give me holy anger about the suffering and loss of human lives! Lives that are so precious to you!

"Are not four sparrows sold for a penny," and yet not one of them falls from the nest without the Father's knowing and caring? "You are more valuable than many sparrows." God said this in so many ways and words but never more clearly than when he bridged the distance by coming into our world and taking on all the humiliation, sorrow and suffering of it.

"Lord, make Calvary real to me," the songwriter pleaded in words we sometimes sing with little sense of awe or need. What would it really mean if he should make Calvary real to us? How would it change our lives, our priorities, our passions?

On Second Thought

I'm not sure I want you to
make Calvary real to me—
scourging whips and nails,
curses and the cursed tree.
Stale sweat, clotting blood
and Jesus falling on the road.

Do I really want to hear
the jeering shouts and cries,
see timeless love impaled
and terror in children's eyes?

79

I cringe as mighty mountains shake—
and Jesus dies for mankind's sake.

But Calvary must be real,
as real as sin's deep stain,
and we must take its dread scenes in
if we would rise and live again.

The Needle's Eye

Imagine a camel passing through the small eye of a sewing needle! Mark and Luke also contain the record of these astounding words spoken by our Lord. It is doubtful that any writer, having heard them, could forget them. The Scripture says that those standing by were astonished, wondering who then could be saved. But it is possible, indeed probable, that Jesus was referring to the small portal that stood next to the main city gate.

"It is easier for a camel to go through the eye of a needle than for a rich man to enter the kingdom of God."
Matt. 19:24

These small portals were left open at night, admitting a straggler into the gates after curfew. But no army could pass through. One could enter only by first taking off any weapons or burdens and passing them through the confining gate ahead of them. When it was confirmed that a soldier was utterly without means of self-defense, he would be allowed to enter. He was totally at the mercy of the city.

The picture would have been especially poignant to Jesus' contemporaries who depended upon the gates to secure their safety from their enemies. Perhaps many of them had used the needle's eye themselves. The image speaks of submission—utter and complete submission. When we repent of our sin and submit to the needle's eye, we are at the mercy of our great Savior, completely dependent upon him.

We are reminded of a similar saying of Jesus: "Unless you change and become like little children, you will never enter the kingdom of heaven" (Matt. 18:3). This saying troubles us slightly less than the one about a rich man entering heaven, but is it really any more difficult for adults to become children than for a rich man to give up his riches?

While the haunting needle's eye prophecy followed Jesus' encounter with the rich young ruler, I'm convinced that he meant us to understand that placing our trust in anything but God would exclude us from his fellowship.

Had little children, who likewise would have posed no threat to the fortified city, sometimes passed through the small opening next to the city gate? Implicit trust is the child-like quality we are called to imitate. Faith that obeys a loving Father's commands, even when it seems unreasonable or dangerous. What parent has not been awed to witness the unremitting trust of a child?

Christ demands our full allegiance. If riches or fame, position or honor take precedence over him, we cannot be his disciples. Who said Christians use their faith as a crutch? To be a true follower of God requires daring and verve and most of all unquenchable faith.

Thomas á Kempis wrote: "For God will have us perfectly subject unto him, that being inflamed with his love, we may

transcend the narrow limits of human reason." Submission is rooted in love that is unafraid.

What could be strong enough to cause us to give up everything? Only divine love, a love that sent Jesus to a cross to die for us when we had done nothing worthy to solicit such an action. "But because of his great love for us, God, who is rich in mercy, made us alive with Christ even when we were dead in transgressions—it is by grace you have been saved" (Eph. 2:4-5).

The only response to such sacrifice is to give ourselves—wholly, without reserve. Such submission is what caused martyrs to sing psalms at the time of their deaths and Paul and Silas to sing at midnight in a Philippian prison.

Such submission is what will enable us to overcome any tragedy or terror. "In all these things we are more than conquerors through him who loved us" (Rom. 8:37).

Martin Luther prepared to go to the Diet of Worms in 1521 even though friends warned him that such a visit could prove dangerous. Others had been martyred, including Jan Hus who was burned at the stake. But Luther's resolve was firm. He took a stand against the ruling authorities. When ordered to recant his statements against the papacy, he responded courageously, "Here I stand; I can do no other, God help me."

In our own times, a 15-year-old Pakistani Christian was arrested on blasphemy charges, imprisoned, sentenced to death, acquitted and forced into hiding. Extremist Muslims have offered $30,000 to anyone who kills him. When asked why he was willing to put his life in such jeopardy, he said, "I have pledged myself to Jesus Christ. I would risk anything for him."

Christians now enduring persecution in countries like China and Saudi Arabia are powerful witnesses to a love that is un-

afraid. Their confident endurance in the fires of persecution testify to the power of Christ's love and his promise to sustain us in times of trial.

Are we willing to put down all our burdens, including our arsenal of human virtues, and submit to this holy love? Like the soldier seeking sanctuary, will we declare our utter helplessness to save ourselves? If we will, we enter the eternal kingdom of love and light which will never be destroyed. Nor will any power on earth be able to turn us aside.

Life for a Cook

Remember the queen who daily greeted her looking glass with the question, "Mirror, mirror on the wall, who is fairest of them all?"

We would be pretty lost without mirrors in our homes when each day we consult one. We don't necessarily do it with the arrogance of the wicked queen who set out to destroy anyone who dared compete with her beauty, but we want to know how we appear to others. If the mirror reveals a flaw, we do our best to repair or camouflage that flaw and so present ourselves in the best possible manner.

"Anyone who listens to the Word but does not do what it says is like a man who looks at his face in a mirror and, after looking at himself, goes away and immediately forgets what he looks like."
James 1:23-25

We've all heard of the woman who, considering herself hideous, banished from her home all mirrors so that she wouldn't be reminded of her appearance. She therefore re-

moved all opportunity to effect any sort of change or to monitor any progress. Similarly, it would be a worthless exercise if, as James suggested, we simply went away, forgetting what we had seen and made no response or change after having heard or read about Jesus.

But a far more insidious malady is a spiritual blindness that renders the most powerful mirror of all meaningless to many. James compares God's Word to a mirror and suggests that the person who only hears but does not act upon what he has heard is like the foolish man who forgets what he has witnessed.

The first thing we see when we look into God's Word is a reflection of ourselves. Perhaps we treat God's Word with nonchalance because we do not like what is revealed there. The gloomy picture of fallen man presented in its pages is not an image we greet easily.

Isaiah, when he saw the Lord high and lifted up, exclaimed, "Woe to me! … I am ruined! For I am a man of unclean lips, and I live among a people of unclean lips, and my eyes have seen the King, the Lord Almighty" (Isa. 6:5). When in the pages of God's Word we catch sight of God who is altogether pure and holy, we recognize the absolute poverty of our impure selves.

But a clear vision of God will do more than merely reveal our sinfulness. We will see there a sure and overwhelming possibility for beauty through the forgiveness and enabling of the Savior. John pointed to Jesus Christ as he saw the Lord approaching the Jordan River and said, "Look, the Lamb of God, who takes away the sin of the world!" (John 1:29). Look into that Mirror and see the one who takes away your sin, however deep and insidious it may be.

Isaiah wrote about the scope of God's power to forgive in his prophecy. "'Come now, let us reason together,' says the LORD. 'Though your sins are like scarlet, they shall be as white as snow; though they are red as crimson, they shall be like wool'" (1:18).

After Isaiah had seen the Lord, repented and been cleansed, an act symbolized by a seraph picking up a live coal from the altar with tongs and touching Isaiah's lips, Isaiah saw something else. He saw a clear call to service. In response to his Lord's request, Isaiah quickly exclaimed, "Here am I. Send me!" (Isa. 6:8).

A look into the mirror of God's Word has far deeper implications than the mere glance into a piece of glass. Much more is written there. Much more is required in the way of personal sacrifice and willingness to be changed. It may take much penetrating searching, perhaps many a sting by the burning coal from God's hand. But the result will be worth infinitely more than any sacrifice. We can be conformed to the very image of God himself in purity and purpose that is eternal.

"No eye has seen, no ear has heard, no mind has conceived what God has prepared for those who love him" (1 Cor. 2:9). Still, many are like the man James referred to. They hear the Word of God. Yet, they walk away, forgetting what they have seen. How tragic to miss life, for as the first stanza of Amelia M. Hull's hymn reminds us, "there is life for a look at the crucified one."

> *There is life for a look at the crucified one,*
> *There is life at this moment for thee;*
> *Then look, sinner, look unto him and be saved,*
> *Unto him who was nailed to the tree.*

The Years of the Locusts

Sally came to our meeting that first evening because she really had no place else to go.

Maude Brown, who brought her, was known as a sort of collector. Not a collector of stamps or antiques, but of people. We'd grown used to seeing the odd assortment of folks who latched onto Maude.

"I will repay you for the years the locusts have eaten ... And you will praise the name of the LORD your God, who has worked wonders for you."
Joel 2:25-26

Sally was one of those. At 37 she could have passed for 60. Blond hair like hay left blanching in a field stuck out at all angles around a lean, pockmarked face. Eyes that might once have been pretty were dulled by too many drug-filled days and nights. Her figure had been mistreated with too many starches and too little exer-

cise. She'd made a stab at dressing up, but in a wrinkled spaghetti-strap dress and no stockings, the effect was ludicrous.

Married four times, the first at age 15, she now lived alone on public assistance. Two children had died. A third was being raised by a grandparent after Sally's latest bout with mental illness. Sally smiled when you spoke to her—a smile that never quite reached her eyes. Shoulders drooping with the weight of her past and present, she echoed a life that was defined by abuse, poverty, loneliness.

But then she met Maude, who lived down the street, and found in her someone to trust, someone to care. Maude was never put off by things that shocked others. Perhaps because she herself had been lifted from a life that held little promise, she knew what was possible. She knew and believed more than most of us. She introduced Sally to the only one who could reverse the downward spiral of Sally's life.

We watched with amazement as Sally began to stand a little taller, to speak without turning her eyes away, to care about things like clean laundry and flowers in a plain white vase. One day she sang a simple hymn with a tremor and a tear in one brightening eye. It was her favorite song, perhaps because she related well to Mary's despair when in the garden, the one she loved could not be found and to her sudden liberation from loneliness when the risen Lord calls her by name. "I come to the garden alone ... And he walks with me and he talks with me, and he tells me I am his own." Sally was on her way toward wholeness, toward a life that was fulfilling and good.

We shouldn't have been surprised. It's what the Lord has promised in his Word. Among the loveliest in all Scripture are those words from the book of Joel: "I will repay you for the years the locusts have eaten."

Like a great horde of locusts, sin had eaten away the joy and wonder of a young woman's life! It had taken her health, her beauty, her children. It had left her aching, empty, lonely and sick. But God took away that sin at great personal cost—his life—and gave her back something beautiful in its place.

God's promise is for all of us. None of us is outside his grace—not the worst infidel who ever lived. Not Sally. Not you. Seldom does he change every circumstance in our lives in a moment, though justification comes in a blink of an eye when we acknowledge our state and lean on his mercy. But God's timing is always perfect, always to be depended on.

Someone has wisely said, while God will repay us for the years the locusts have eaten, we may have to get rid of the locust. It does no good to lament our sin unless we are willing to turn from it—to banish it from our lives. This he gives us the strength to do, but we must be earnest in our resolve to live lives pure and pleasing to God.

"Beauty instead of ashes, the oil of gladness instead of mourning" (Isa. 61:3). Only in God's economy can such grace, such abundance exist. Give him an opportunity to restore what sin has taken from you. And give praise to the Lord for his unspeakable gift of love.

The Homecoming

Jesus' frequent references to himself as the Way, the Door, Bread, Salt and Light are all symbols of a larger imagery—home. God yearns to welcome us to himself—to our Home. Humble, penitent prayer transports us across the threshold, as the publican of Scripture discovered.

> *"I am the way and the truth and the life. No one comes to the Father except through me."*
> John 14:6

It was a day like any other. Merchants unloaded goods from balking camels, and women and servants haggled in the teeming market place. Boisterous children scrambled among stalls of vegetables and linen, occasionally hiding among the sacks or snatching an unguarded fig or pomegranate.

Men shuffled toward the temple for prayer, some thinking of the goods they would sell that day. Others strode in solemn silence, full of duty. Coins rattled and clinked in their purses as they approached the temple's outer court. Beggars lurched forward in ragged appeal.

One man walked alone, eyes down. If he were recognized, people would step aside or spit on him as they passed. In Jerusalem, the tax collector was the most despised of all men— a brigand, robbing his own people.

He watched the city's leading citizens strutting toward the temple, arms folded across their long tunics. Fringes, intended to remind wearers of the commandments, swayed and slapped against the tax collector's legs like a curse as they passed him.

He hesitated. It had been a long time since he had given thought to the commandments he had memorized as a boy. Why was he thinking of them today? What was he doing here anyway at the hour of prayer? He hadn't meant to come. But something he couldn't name compelled him.

Was it true that all people prayed? Maybe they didn't think of them as prayers—those broken fragments uttered when something terrible happened and they said, "Oh, God!" Or those poor crippled prayers hidden in blasphemies, as though they still must speak to God, if only through clenched teeth.

The publican saw all this in a moment of epiphany. What was strong enough to draw him toward the temple like this? Who was strong enough? Jehovah? But he could not utter the syllables of his name.

He watched the Pharisees lift their arms as they neared the temple. He could see little scrolls of parchment containing God's laws bound on their wrists and foreheads. The Jews took literally the command to "tie them as symbols on your hands and bind them on your foreheads" (Deut. 6:8).

The publican could almost feel the words burning into his brain, searing his soul even as the hot sun blazed down on his head. He had not worn the scrolls—on his forehead or in his heart. Now his soul longed for the commandments—more

properly, for Jehovah. He longed for him as for the beckoning lights of home.

The chanting grew louder. He stopped short. He could not approach the holy place. Maybe *they* could go, praying their loud prayers, swishing their long-fringed robes as the little scrolls bobbed between their eyes. But he could not go. He could not even lift his eyes to heaven.

Someone turned in his direction and began to pray in a loud voice. "God, I thank thee that I am not as other men are, greedy, unjust, adulterers, or even as this publican."

The publican felt his pulse quicken, his eyeballs throb in their sockets. Yes, he was guilty. If it was true that prayer is a man's impulse to open up his life before God at its deepest level, then he wanted to pray! It was as though he had been on a long journey and, remembering the lights of home, longed for waiting arms and shared intimacies.

He nearly doubled over in his soul agony as the pious voice continued: "I fast twice in the week: I give tithes of all that I possess!"

The words were swallowed by the loud beating of his heart. A hot iron seared his conscience. And his longing for his soul's home swelled in his heart like waves breaking against a dry shore. He beat upon his chest—the symbol for being struck dead—the punishment he knew he deserved. He dropped his head on his chest and whispered, "Lord, be merciful to me, a sinner!"

It seemed an eternity was in the moment. How long he stood there he couldn't have told. But he knew in one great wave of grace the sense of being carried across a threshold and swept into the home of his longing where God waited to welcome him.

Under His Wings

One of the most vivid scenes in my memory occurred one lazy summer on my uncle's one-hundred-acre farm in Michigan. My brother and I were in luck because my aunt, who cared for the farm's poultry concerns, had just purchased 50 baby chicks to raise. These soft little balls of yellow seemed like dandelion fluff blown across the prairie in the summer wind.

> *"O Jerusalem, Jerusalem, you who kill the prophets and stone those sent to you, how often I have longed to gather your children together, as a hen gathers her chicks under her wings, but you were not willing."*
> Matt. 23:37

By the hour we watched the tiny creatures peck grain and draw at the water tubes. On warm days they were confined in a chicken run where they could hop about and forage in the gentle sunshine. They stumbled after their fat, strutting mammas and seemed to grow bigger before our very eyes.

Aunt Dina decided to leave the chicks in the run one after-

noon when we went to town. We'd been to J.C. Penney's and the local feed store and were on our way to the A & P when the clouds gathered with startling suddenness. Thunder rumbled down the valley, and the sky exploded in a vehement rain such as we had never seen before.

Aunt Dina drove home, her face drawn and grim. We knew she was dreadfully worried about the chicks. And her worry was not without cause, for when we pulled up the drive and raced to the chicken run, we saw the tiny yellow things in grotesque contortions, some struggling to get up, others still as death under burial sheets of rain. Two of the three hens nestled on the ground with glassy eyes and bulging sides— bulging because of the chicks gathered beneath their rain-soaked wings.

One hen scuttled nervously around a group of struggling chicks, and those she'd already gathered were dragged along as she frantically attempted to draw the others in.

Aunt Dina lost twenty-five of the fifty chicks. Most of those sheltered beneath mamma's wings were still alive. We nursed them back to health under heat lamps in the living room.

The sight of that one desperate hen, her eyes wide and glassy with fright, wings scraping the ground as she chased the scattering chicks, is a memory as vivid today as it was then. For it is so like the scene Jesus described as he wept over Jerusalem.

Like my Aunt Dina's chicks, the people of Jerusalem who heard Jesus speak had no idea of the storm that was coming. They didn't believe that they needed him, that their lives depended on him in spite of the warnings of Jesus and of the prophets before him. They turned away, refusing Jesus' love and protection.

This is a picture of love and mercy, of our relation to God as children, becoming his sons and daughters. Author George MacDonald speaks about sonship in his book *Creation in Christ:*

> God can no more than an earthly parent be content to have only children. He must have sons and daughters— children of his soul, of his spirit, of his love—not merely in the sense that he loves them ... but in the sense that they love like him, love as he loves. For this he does not adopt them. He dies to give them himself, thereby to raise his own to his heart. He gives them a birth from above; they are born again out of himself and into himself.

It was for this position in the very heart of God that we were made, and we shall never be safe or happy or free until we allow him to gather us to himself. The chicks that refused the life offered beneath their mothers' wings were indeed offspring. But only those that allowed themselves to be gathered in remained to live and to share the life of their mother.

There is no life worth having but that which is eternal life— God's life. "But as many as received him, to them gave he power to become the sons of God, even to them that believe on his name" (John 1:12 KJV). There is life nowhere but in him, however enticing the bawdy emptiness of other forms.

Perhaps we fear the closeness of him may stifle us, make of us little carbon copies that deny our uniqueness. The contrary is true, for we read that if Christ makes us free, then we are indeed free—free to become all we can be in the limitless providence of him who is *all.* Paul reminds the Colossians: "For in Christ all the fullness of the Deity lives in bodily form, and you have been given fullness in Christ, who is the head

over every power and authority" (Col. 2:9-10).

God does not offer us merely a shelter in the midst of turmoil. Revealed in the potent image of the hen with her chicks is the possibility of taking part in the very life of God.

A Long, Cool Drink

The sun bounced off centuries-old rock as we braved the stifling heat of the old city. Historic Jerusalem abounded with captivating sights, like the famous wailing wall where since ancient days devout Jews have come to pray. Bells from a nearby mosque struck three—the hottest part of the day.

> *"Come, all you who are thirsty. Come to the waters; come, buy and eat! Come, buy wine and milk without money and without cost."*
>
> Isa. 55:1

It was midsummer, and no breeze stirred. Native citizens, often sporting several layers of clothing, went about their business, unaffected by the wilting heat. But we tourists were ready to drop with heat exhaustion.

Then, suddenly, there were street vendors peddling icy-wet bottles of Coca-Cola. They filtered among us, calling out their wares. Each had only a few bottles held in deft, brown hands. We scrambled for our money, grasping for a coveted drink. My friend and I paid the equivalent of $2.00 each for

an eight-ounce bottle of Coke!

In Jerusalem at that time, it was customary to dicker with merchants to determine a price. We paid an exorbitant sum, simply because we were too hot and thirsty to protest. Only in retrospect were we stunned by the high cost. At the time, our thirst superseded any other concern.

Jesus' words come to mind: "Blessed are those who hunger and thirst for righteousness, for they will be filled" (Matt. 5:6). God created us with a natural thirst for goodness, a longing to know him, the source of all that is good. This innate sense is what separates us from all other created things. We are persons made in the image of God. We are naturally hungry to know him.

"By nature, every creature seeks to become like God," wrote Meister Eckhart in *The Choice Is Always Ours,* "Nature's intent is neither food nor drink nor clothing nor comfort nor anything else in which God is left out. Whether you like it or not, whether you know it or not, secretly nature seeks, hunts, tries to ferret out the track on which God may be found."

Though sin has marked us with other desires and passions of remarkable intensity, there remains within the most unholy a certain echo of Eden—a sense that we were created for some good purpose. Sometimes that purpose eludes us for a major portion of our lifetimes, and sadly, some never find what all their lives they have been seeking.

God has called to us down the long hallways of history—instructed us through a host of created wonders that testify of him. He has sent the prophets to speak for him, whispered in the ears of saints and sinners, and eventually descended into our cosmos to move among us.

None of it was sufficient to move us—nothing but the blood

of God himself spilled out for the healing of our love-starved souls could bridge the terrible gap sin had created between man and his Creator.

People today are thirsty—indeed dying of thirst. They reach for water in a thousand wells—fame, money, pleasures, relationships—and find their longing unsatisfied. Scripture and human experience attest that when we truly want to know him who is the true wellspring, he will make himself known to us.

"You will seek me and find me when you seek me with all your heart" (Jer. 29:13). There are no promises for the casually curious or the spiritually lazy.

Sincerity of heart and determination of mind are intrinsic to loving God. In dealing with his people, God told them over and over again, "Love the Lord your God with all your heart and with all your soul and with all your strength" (Deut. 6:5).

It was said of Abraham, Enoch, Sarah and others who chose to diligently seek the Lord, "They were longing for a better country—a heavenly one. Therefore God is not ashamed to be called their God" (Heb. 11:16).

How eager our Father is to give himself to us. He longs to live intimately with us, but he will make no casual acquaintances. He honors our desire to know him and our determination to love him faithfully and obediently.

Before we had circled the temple area in the old city of Jerusalem, we were again thirsty. But the living water that flows from our Savior "will become ... a spring of water welling up to eternal life" (John 4:13).

Are you thirsty for water that satisfies, water that lasts? He who loves us with an everlasting love has bid us come to him and live.

The Cup of Trembling

Few descriptions have so captured the imagination as this one from the book of Isaiah. Many writers have incorporated the image, as James Baldwin did in his much-anthologized short story "Sonny's Blues." "The cup of trembling" inspires an altogether terrible, yet wonderful, resonance in the soul. Throughout Scripture the cup is used metaphorically as a figure of a man's lot, of a nation's great riches, or in the case of Isaiah 51:22, of God's fury.

"Thus saith thy Lord ... thy God that pleadeth the cause of his people, Behold, I have taken out of thine hand the cup of trembling, even the dregs of the cup of my fury; thou shalt no more drink it again."
Isa. 51:22 KJV

Adding poisonous or intoxicating substances to wine was an ancient method of confounding one's enemies or putting them to death. So it was that a king appointed his cupbearer to test the contents of the drinking utensils in order to safeguard the health and life of his sovereign. The office of cup-

bearer is of great antiquity, mentioned in connection with the courts of Pharaoh, Assyria, Persia and Israel.

Isaiah used the powerful picture of contaminated wine to indicate that the Israelites must drink the cup of the terrible fury of a righteous God because of their continued disobedience, idolatry and lust. "Awake, awake, stand up, O Jerusalem, which hast drunk at the hand of the LORD the cup of his fury; thou hast drunken the dregs of the cup of trembling, and wrung them out" (Isa. 51:17 KJV). The New International Version calls the cup which they must drink to the last drop "the goblet that makes men stagger."

Old Testament history is replete with accounts of Israel's failure to wholly follow the Lord. God had promised them victory over their enemies as long as they obeyed him and did not turn to foreign gods. But hardly had his voice ceased vibrating in their ears and they were bowing before their golden calves or genuflecting at some abominable Asherah pole.

In this century we find ourselves vulnerable to the allure of equally appalling gods. Money, power, sex ... these and others vie for first place in the hearts God designed for himself. Hardly aware that we have sacrificed the highest good on a demoralizing altar, we come to a place of weakness, trembling. We cry out with Paul as we drink the bitter brew of our own faithlessness, "Who shall deliver me ...?"

In Gethsemane Jesus drank the terrible cup of God's fury. There, as he contemplated the Cross and the awful burden of the world's sin, he prayed, "My Father, if it is possible, may this cup be taken from me. Yet not as I will, but as you will" (Matt 26:39).

It was a cup poured for us who had turned away from God's righteousness. To drink it carried the ultimate curse, for

"the wages of sin is death" (Rom. 6:23). But Jesus drank the cup and bore the curse for us all, conquering even our most feared enemy. Richard Slater's well-known song, "What a Savior," expresses the wonder of this truth:

> *None the love of Christ can measure,*
> *None its depths can ever tell,*
> *None can estimate the treasure*
> *Held by those who with him dwell.*
>
> *Hope each guilty soul may cherish,*
> *Trembling hearts need not despair,*
> *Jesus died that none might perish,*
> *He for all sin's curse did bear.*

"I have taken out of your hand the cup of trembling," God says to us today. There is no need to drink it, for he has tasted death for you and for me.

Barren Cornstalks

The Iowa cornfield stretched for miles, a rich blend of tall green stalks and yellow ears about to be harvested. It would have been one of the richest and finest that year had not the devastating tornado ripped through its heart, stripping bare the stalks. When the whirlwind had passed, the cornstalks stood naked in the shattering calm.

> *"They sow the wind and reap the whirlwind. The stalk has no head; it will produce no flour. Were it to yield grain, foreigners would swallow it up. Israel is swallowed up; now she is among the nations like a worthless thing."*
>
> Hos. 8:7-8

Perhaps the prophet Hosea had seen a similar disaster when he penned his word picture centuries ago. The Israelites had exchanged the living God, who had brought them out of slavery into freedom, for idols of gold and stone. They grew to love the sacrificial rituals with all their pomp and sensual excitement. They mocked those few holy people who continued to revere God. "The spiritual

man is mad," they said.

Thus the Israelites became barren cornstalks, stripped of their freedom and prosperity as God allowed them to reap the natural results of their foolish choices. They were conquered by their enemies, easy prey in the hands of greedy nations.

Hosea declared, "You have planted wickedness, you have reaped evil, you have eaten the fruit of deception. Because you have depended on your own strength and on your many warriors, the roar of battle will rise against your people, so that all your fortresses will be devastated" (Hos. 10:13-14).

Their plight is mirrored in the lives of individuals and nations today. Something has happened to the traditions of honesty, purity, valor, truth. A loss of values, both public and private, have undermined society's primary institutional supports. Because we have forgotten God, the whirlwinds of life blow across us, stripping us of inner resources, and we become easy prey for our soul-destroying enemies.

Russell Kirk has written: "A good many people fret themselves over the rather improbable speculation that the earth may be blown asunder by nuclear weapons. The grimmer and more immediate prospect is that men and women may be reduced to a sub-human state through limitless indulgence in their own vices—with ruinous consequences to society."

In his hard-hitting book, *Against The Night*, Charles Colson writes that we face a crisis in Western culture, a culture that has declared God dead and the individual master, a culture of new barbarians and a moral system established solely on human reason.

"While such new barbarians who know no higher law than self-interest, who see nothing to champion beyond their individualism, are celebrating their own nihilism, they are, in ef-

fect, torching the very props of virtue on which our societal experiment—and our very existence—depend."

The prophet Hosea appealed to Israel to "Return ... to the Lord ..." who will "heal their waywardness and love them freely." At that time, "Men will dwell again in his shade. He will flourish like the grain ..." (Hos. 14:1, 4, 7). No longer barren cornstalks, raped of all that is good and useful, they will blossom and grow and be sustained.

As it was in Hosea's day, so now God continues to hold out his compassionate arms to a wayward generation, longing to bring them to himself again. "For he is patient with you, not wanting anyone to perish, but everyone to come to repentance" (2 Pet. 3:9). It is sin that turns us inward and away from him who is our Source, our very life. God, in the form of man, suffered and died to destroy sin, making it possible for us to live.

No one need be decimated by the storms which will indeed rage as long as there is life on earth. God is our source, our sustenance, and he will enable us to "flourish like the grain."

Our Place in the Son

It was the hottest day on record in Washington. Few people ventured out on the blistering sidewalks that sent up a nearly visible steamy mist. Factoring in the humidity, the index reached 111 degrees.

> *"Foxes have holes and birds of the air have nests, but the Son of Man has no place to lay his head."*
> Luke 9:58

Perhaps the weather heightened the odd appearance of the old man dressed in a winter flight jacket with fleece collar. He carried his belongings on his back and shuffled along the street, his complexion nearly beet red.

Unfortunately, homeless persons are no oddity on our nation's streets. Although they have always been with us, we are becoming more keenly aware of their plight in recent years. Some two million people are homeless over the course of a year—736,000 on any given night, estimates the National Alliance to End Homelessness.

Imagine that the entire population of Austin, Texas, were to become homeless, and you will have an idea of the magni-

tude of the problem. Families make up about one-third of those who are homeless. At least 100,000 children are homeless.

If anyone understands the woundedness, the perplexity, the terror of the homeless, I suppose Jesus does. He left the splendor of Heaven. He experienced the coldness, the hardness of life in a fallen world. He knew what it was to suffer loss, to bear rejection, to be considered useless or a danger to others.

And how tenderly Jesus dealt with those who were beaten down by a power-conscious, materialistic society. He had nothing but censure for those who abused the poor, who contributed to the discomfort of others.

Close to the end of Jesus' Galilean ministry, the disciples witnessed Jesus' transfiguration on the mountain. In a moment of passion, one of them said, "Lord, I will follow you wherever you go."

But Jesus knew they had not yet understood his mission or given their complete loyalty. They were not fully aware that discipleship must take precedence over material comforts, social duties, even family relationships. He reminded them that he didn't even have an earthly home. He was, essentially, homeless.

Or was he? Certainly, he had no address, no post office box, no earnings from his ministry to place in a savings account. He did have a few friends who offered him shelter and food. We read about the home in Bethany where Lazarus, Mary and Martha lived. But Jesus' long, difficult journeys sometimes led through friendless territory. A stone for a pillow and his one seamless robe for a covering on cold, dark nights. Homeless.

Or was he? Is homelessness only a matter of material dislocation or deprivation? If so, Jesus would certainly fit the de-

scription. If it is disconnectedness from community, a lack of belonging, an aimlessness, a hopelessness, he cannot fit in that category. But many souls seeking spiritual shelter do, whether they live in a mansion or a walk-up.

"I came from the Father and entered the world" (John 16:28), Jesus declared with such authority that people were confounded. He knew exactly who he was and what he was doing. He is the "exact representation" of the Father (Heb. 1:3), the one central point around which all of creation rotates and hangs together.

He is the welcoming hearth, the light in the window, the steaming bread prepared to give sustenance and energy to all who come to him. He is the fixed compass point by which we can steer our lives. As we follow, we are led home to him.

The poet Wordsworth expressed this truth in his memorable lines: "Trailing clouds of glory do we come from God, who is our home." Paul reminds those who believe in him that "When Christ who is our life appears, then you also will appear with him in glory" (Col. 3:4).

God is our home. Physical homes are important, but more vital is the spiritual home. Our eternal souls must outlast this life and nothing is more important than connectedness to him. We have only to accept his gracious gift of life. Of home, where we are open to the wind of his eternal spirit nourishing, sheltering and loving.

Section 3
· · · · · · · · · ·

Life in
Community

The Priceless Pearl

The Arabs hold a superstition that pearls are dewdrops filled with moonlight which fall into the sea and are swallowed by the oysters, then turn from liquid to solid form. These satiny spheres do seem to have the soft gleam of moonlight, but their origin is entirely earthly.

"Again, the kingdom of heaven is like a merchant looking for fine pearls. When he found one of great value, he went away and sold everything he had and bought it."
Matt. 13:45-46

The story of the pearl continues to fascinate us even as it did the first time we learned how a tiny grain of sand, or perhaps a little parasite, works its way into the shell, and gets caught in the soft membrane between the shell and the creature inside. In order to stop the resulting irritation, the mollusk begins to coat the intruder with thin layers of a shiny substance called nacre. Year after year the nacre is deposited on the object in the center until the pearl sometimes grows quite large.

As the mollusk deposits the nacre, its muscles expand and contract in an effort to get rid of the object. This movement has the effect of rolling the object around, so that the nacre is smoothed in even layers and the growing pearl keeps a round shape. Pearls grow in many colors, but the most valued are rose, cream, white and black. A strand of real pearls may cost hundreds of thousands of dollars.

Of course, Jesus, the Creator knew all about the history of a pearl, how it was formed, and its real value. Why did he not speak of diamonds or sapphires or other precious gems in connection with his kingdom? Why the pearl? Surely the fact that the pearl is a product of a living organism gives special meaning here.

Out of much suffering on the part of the mollusk the beautiful pearl is produced. Out of the wounded side of Christ came the Church. Like the mollusk covering the offending thing with a precious substance of its own body, Christ covered our sin with his precious blood, transforming ugliness into beauty. As the little grain of sand is ultimately clothed with a beauty not its own, we are covered with the beauty of him who suffered for us.

Another resemblance between a pearl and the Church is suggested by the fact that the pearl is formed slowly and gradually. There is the tedious process of waiting while the pearl is being formed. Christ's death made possible the formation of the Church, and for more than nineteen centuries the Holy Spirit has been making it actual. Just as the oyster covers the wound in its side with layer after layer of beautiful nacre, so God calls each generation to add to the Church.

The formation of the pearl takes place in secret. Only God watches the oyster transforming an intrusion into a pearl. It is

true also with the Church which Christ is forming. Unknown and unseen, his pearl is being fashioned. Though we certainly can see the organized, visible church of stone or wood, no one can see the Church of the living God. Our life is "hid with Christ in God."

Perhaps when Jesus used the parable of the pearl, he was thinking how the pearl, first embedded in a mass of corruptible flesh, had to be separated and cleansed from its surroundings in order that it might appear pure and beautiful, a fit diadem for a king.

While Christ's Church remains on earth, it is surrounded by a mass of corruptible flesh, but his Spirit is occupied with the purification of his Church which he will ultimately present "a radiant Church, without stain or wrinkle or any other blemish, but holy and blameless" (Eph. 5:27).

As pearls adorn the crowns of monarchs, so in the ages to come Christ will display his own pearls and in them "show the incomparable riches of his grace" (Eph. 2:7). Many fine pearls will be his, but all in Christ are one and will forever be his one pearl of great price. Out of the wounded side of Christ, we are transformed into his likeness and will one day be presented whole and pure in his glorious kingdom. While we wait for him our hearts echo the chorus written by General Evangeline Booth:

> *The wounds of Christ are open,*
> *Sinner, they were made for thee;*
> *The wounds of Christ are open,*
> *There for refuge flee.*

From Small Beginnings

While the seed of the cypress tree is actually smaller, the mustard seed was proverbial in the Middle East for small-ness. The Jews talked about a drop of blood as small as a mustard seed. Some small breach of their ceremo-nial law could result in defilement as small as a mustard seed. And Jesus used the phrase in this way when he spoke of faith as a shoot produced by it.

> *"The kingdom of heaven is like a mustard seed ... Though it is the small-est of all your seeds ... [it] becomes a tree, so that the birds of the air come and perch in its branches."*
> Matt. 13:31-32

There is no exaggeration at all in this parable. Quite unlike the mustard plant of today, the grain of mustard seed in Palestine grew into some-thing of tree-like proportions. Thomson in *The Land and the Book* wrote that he had uprooted a mustard-tree that was more than 12 feet high. It was also quite common to see such mus-tard bushes or trees surrounded by birds who love the little black seeds and settle there to eat them.

Jesus declared in this parable that the kingdom of Heaven starts with the smallest beginnings, but no man knows where it will end. It is common in the Old Testament to picture a great empire as a tree, with subject nations shown as birds finding shelter within the branches. Of Assyria it was said, "It towered higher than all the trees of the field … All the birds of the air nested in its boughs" (Ezek. 31:6).

An idea sown in the mind of one person can change life for hundreds of thousands of people. Consider the little-known hermit of the desert, Telemachus. Not knowing why, this little monk responded to the call of God to travel to Rome. Though nominally Christian at the time, Rome held the gladiatorial games in which men fought each other to the death.

To his horror, Telemachus found 80,000 spectators roaring with the lust for blood. He leaped from his seat into the arena and stood between the gladiators. He was tossed aside again and again as the crowd surged with anger; and then they began to stone him. "The prefect's command rang out; a sword flashed in the sunlight, and Telemachus was dead," writes William Barclay. "There was a hush; suddenly the crowd realized what had happened, a holy man lay dead." From that day, gladiatorial games ceased. One man had by his death cleansed an empire of a great sin.

Christianity, of course, started with one Man who began in the smallest of ways. Coming as a helpless infant suckled at a human breast, he ushered in a kingdom so great it has no end. Isaiah prophesied, "The government will be on his shoulders, and he will be called Wonderful Counselor, Mighty God, Everlasting Father, Prince of Peace. Of the increase of his government and peace there will be no end" (9:6).

And what a difference that one life has made! There is

nothing in history so unanswerably demonstrable as the trans-
forming power of Christianity and of Christ on the lives of
individuals and society. But there was a time when Isaiah's
prophecy seemed empty. To all human perception it seemed
that Christ's reign had come to an end on a Jerusalem hill. But
it had only begun.

Jesus gave the mustard seed parable to his disciples who
must have at times despaired when they considered the enor-
mity of their task to carry the gospel message into all the world.
Their little group was so small and the world so wide. Jesus
was saying to his disciples that there must be no discourage-
ment, that they must serve and witness each in his place.
Each of us must be the small beginning from which the king-
dom grows until the kingdoms of the earth finally become the
kingdom of God.

> *They shall come from the east,*
> *they shall come from the west,*
> *And sit down in the kingdom of God;*
> *Out of great tribulation to triumph and rest*
> *They'll sit down in the kingdom of God.*
> *From every tribe and every race,*
> *All men as brothers shall embrace;*
> *They shall come from the east,*
> *they shall come from the west,*
> *And sit down in the kingdom of God.*
> *—John Gowans*

Upright in a Bent World

We all sang the little rhyme as children: "There was a crooked man who walked a crooked mile ... He laid a crooked sixpence upon a crooked stile ... He had a crooked cat that caught a crooked mouse ... and they all lived together in a little crooked house."

The nursery rhyme has a lilting rhythm that tends to happily camouflage the import of the story. The words trip evenly off our tongues and glide away into pleasant little rivulets of childhood memory.

Undoubtedly, the writer meant the rhyme to be just that: pleasant sounds that sing in our memory. Yet, there's some-

> *"Every valley shall be filled in, every mountain and hill made low. The crooked roads shall become straight, the rough ways smooth. And all mankind will see God's salvation."*
> Luke 3:5-6

127

thing almost sinister in the image of a crooked man in a world of crooked things. One wonders what the man's world might have been like had he been straight. Would he have walked a straight mile? And what of the money with which he paid the toll? Was he crooked because everything around him was crooked, or was everything around him crooked because he was crooked? Was it even possible for him to be straight in such an overwhelming complexity of crooked things?

Perhaps the rhyme doesn't deserve such petty questioning. But something much more pertinent, much more vital, comes to our minds if we pursue this prattle a bit further.

C.S. Lewis speaks of our environment as a "bent world," one which, though created perfect by a perfect Creator, has become distorted to the point that perhaps the concept of "perfect" barely makes sense anymore to our imperfect minds.

The "stained planet" is our home now and it is hard to walk in it without becoming tainted, but the divine image in us yearns to walk uprightly, to do what is pleasing to our Creator. There is within all of us a faint echo of Eden, a sense that we were made for something much better, for some eternal purpose.

John the Baptist, as he descended upon the crowds with his particular brand of prophetic thunder, quoted the words of Isaiah and called people to a baptism of repentance. He challenged them and us to live upright in a bent world. But how shall this be done?

"Who may ascend the hill of the LORD? Who may stand in his holy place? He who has clean hands and a pure heart" (Ps. 24:3-4).

We throw up our hands in despair. Like the little boy who meant to stay clean until mother came for him, we find our-

selves mussed and misshapen, dirty, and walking a very crooked mile!

"How shall a young man cleanse his way?" the psalmist asked. The answer is in the pronouncement that followed John the Baptist's challenge to live uprightly: "Behold the Lamb of God who takes away the sin of the world." As Jesus emerged upon the green hills of Galilee, the Baptist pointed his own disciples to this one who would show us how to walk uprightly in a bent world.

Though surrounded by evil at every turn, Jesus clung solidly to the path of righteousness. In the midst of sin, he remained pure and true. And the righteousness of that one, Jesus Christ, has been imputed to us because of his death and resurrection.

"For the grace of God that brings salvation has appeared to all men. It teaches us to say 'no' to ungodly passions, and to live self controlled, upright and godly lives in this present age, while we wait for the blessed hope; the glorious appearing of our great God and Savior, Jesus Christ, who gave himself for us to redeem us from all wickedness and to purify for himself a people that are his very own, eager to do what is good" (Titus 2:11-14).

Is it possible to be upright people in a bent world? What kind of God would demand what we could not accomplish? He proved that we could accomplish it, and at this moment continues to empower and enliven the spirits of men and women who choose to follow him, who choose to walk upright in a bent world.

The Easy Yoke

Farmers in Jesus' day knew that a good working team of oxen often stood between starvation and well-being. If one of the beasts refused to cooperate, the arduous work of harrowing, planting and cultivating could not be accomplished.

"Take my yoke upon you and learn from me ... For my yoke is easy and my burden is light."
Matt. 11:29, 30

My uncle had a team of horses that pulled the hay wagon and helped him clear heavily wooded areas. During our summer visits to the farm, we loved to watch him work with Champ and Casper—sinewy, thick-haunched animals with amazing stamina. They were incredibly strong creatures, their muscles rolling and turning with the demands of their task. Often after a particularly difficult task was done, my uncle would jump down from the box and affectionately slap the horses' sweaty flanks. And they in turn would nuzzle his pockets for the treats he invariably carried for them.

Uncle Bill took special care with the wooden crosspiece

and harness that bound Casper and Champ together. He'd sand away any rough spots in the wood and oil the leather parts until they were soft and pliable. And at the end of each day he checked the animals' flesh for sore or chafed spots. Then the horses would be bedded down in clean stalls with plenty of feed and water. Casper and Champ were inseparable yokefellows, seeming almost to understand their common task and revel in it. And they were treated with respect and rewarded for a good day's work.

Paul used the word "yokefellow" to characterize people whose lives were bound together for a common mission (Phil. 4:3). The Christian life was meant to be lived in community. No lone rangers. Empowered by the same Spirit, it is the Christian's duty to labor not to develop private empires but to harvest souls for God's great kingdom.

In marked contrast, John warns readers in his first epistle about a man named Diotrephes. He "loves to be first," the apostle writes. Far from being a yokefellow, this one did not pull well in the double harness, but rather hindered progress.

William Barclay notes that it was a practice among first century Greeks to discard their pagan names and upon baptism take Christian ones which described their new Christ-moulded characters. It is significant that Diotrephes retained his old name which meant "nourished by Zeus"—the principal god of the Greeks. This could indicate that Diotrephes never intended to take up the Lord's yoke of servanthood.

When we take on the name of Christ, we identify as his servants, pledging ourselves to follow him, whatever that might mean for us. When one of the Twelve became curious about the fate of a fellow disciple, Jesus rebuked him. "What is that to you?" he admonished. "You must follow me" (John 21:22).

"My yoke is easy and my burden light" (Matt. 11:30), said Jesus. Surely he never said that the work would not be difficult, the nights long, the sun's heat intense and our energies severely tested. For some the hazards of being joined to him would mean death.

In many countries of our world today, Christians are being imprisoned, tortured and put to death for taking a stand for Jesus Christ. Yet, these who so desperately need help, protection, saving, are asking us to pray for boldness in declaring their faith. They're not asking for relief. To us who enjoy liberty and comparative ease, this is a wake-up call to our faith and an affirmation that God makes bearable what would otherwise be unbearable as we serve together.

What our Lord did mean to tell us is that his presence would make our service not only bearable but joyful and provide rest from our labors. "Come unto me, all you who are weary and burdened, and I will give you rest ... For I am gentle and humble in heart, and you will find rest for your souls" (Matt. 11:28-29).

With remarkable tenderness Jesus pours the ointment of his love and blessing upon us. He enables us to work for him through gifts chosen especially for us, through the fellowship and sustaining of brothers and sisters, through his own healing spirit in place of our meager human resources. When pressed down with the weight of our toil or wounded in some desperate battle, he comes with his healing. With his presence. With his rest.

Let All Creatures Praise

These delightful personifications dance through the prophecy of Isaiah and vibrate with the joy that would attend the coming of Messiah to earth. "The whole earth is full of his glory," the psalmist recorded earlier, but in a unique sense, creation itself would respond with praise when the Word became flesh and dwelt himself among men.

> *"You will go out in joy and be led forth in peace; the mountains and hills will burst into song before you, and all the trees of the field will clap their hands."*
> Isa. 55:12

Creation is witness to the existence and order of God, to his majesty and unequaled beauty. Everything in it speaks of its Maker and praises him. David wrote: "The heavens declare the glory of God; the skies proclaim the work of his hands. Day after day they pour forth speech; night after night they display knowledge" (Ps. 19:1, 2). Those who see and listen find their hearts strangely drawn to the Maker of earth's wonders.

Austrian-born composer Gustav Mahler created nine finished symphonies of extraordinary power and beauty, including his well-known *"Das Lied von der Erde"* ("The Song of the Earth"). His intimacy with nature resonates through his music. His orchestral innovations mimic the sounds of birds and brooks and wind.

Born a Jew, Mahler became a Christian in his later years. Historians cannot determine exactly what led to his conversion, but they do tell us that young Gustav was an abused and neglected child, that he spent a great deal of time in the woods near his home.

There among the trees and flowers, the mountains and rivers, Mahler listened to God; he learned much about the Maker of earth's wonders. Who can doubt that Mahler's spirit was not singularly touched during those boyhood years when he fled to the arms of nature for the solace and comfort he so desperately craved.

At 55, when Mahler was conductor of the New York Philharmonic Symphony Orchestra, he suffered a physical collapse. His physician concurred that his heart was very weak and that he would probably not survive. Strangely, Mahler continued to work with great vigor, telling his family and colleagues that he would live forever. They thought his protestations ironic and sad, for two months later Mahler was dead. But one cannot listen to the majestic "Resurrection Symphony" without a sense of knowing that what Mahler said was true, that he would truly live forever—in a real and spiritual sense— a truth first learned from the rivers and mountains, the trees and woodland creatures.

Trees "clap their hands" in natural response to the Creator. Winds whistle through leaves in a symphony of praise.

. .

People, responding in love to their Maker, worship him with hearts full of gratitude for his being and his works. "Worship," says John Henry Jowett, "carries us from the confines of our limitations to the infinity of God's power, carries us from our blindness to God's illumination, leads us away from our imperfection to God's purity and from our frustration to God's transcendence." When we finally see him with the eyes of the spirit, our natural response will be to praise him, both with our lips and hearts, and also with the offering of holy lives.

Our holy lives will be a continual fountain that not only satisfies our spiritual hunger but draws thirsty souls to our Lord. Jesus promised "... whoever drinks the water I give him will never thirst. Indeed, the water I give him will become in him a spring of water welling up to eternal life" (John 4:14). Once we drink of his spirit, his life, our joyful response will spring from that living well within.

We will not need to force ourselves to love him, to be thankful, to allow this precious gift to flow over into the lives of others. We will spontaneously spill over with joy and concern for others. The question is, have we really invited him to dwell with us, to permeate every area of our existence, so that he is complete in us?

We inherit a life of praise once we have drunk of the living water. Like the mountains and hills, the valleys and the trees, we will be possessed of a joy that never fades; we will clap our hands in worshipful praise.

The Normal Solution

A summer home we often visited sits on a hill on the edge of a small northern town built by the logging industry over a century ago. The river that brought it economic success is still the predominant feature of the area, offering fishing, swimming, boating and camping. Mother, in love with the town's noble serenity, bought the house more than 30 years ago, retired there, and welcomed visits from children and grandchildren.

> *"You are the salt of the earth. But if the salt loses its saltiness, how can it be made salty again? It is no longer good for anything, except to be thrown out and trampled by men."*
>
> Matt. 5:13

When she inherited a new home in heaven, the old house was our legacy. But since we lived hundreds of miles away, the house stood largely unoccupied, tended occasionally by a hired handy-man. During the summers when the children were young, we enjoyed swimming in the Flambeau River, taking our nightly walks along the railroad tracks to the center of the

little town with its A & W Rootbeer stand and then returning to the solitude of the house with its sheltering oaks.

When we first arrived in the summer, we were greeted with a stuffy, dusty atmosphere. But cooking always seemed to breathe new life into the old house. We'd witness a transformation as we shared supper on the first night of our vacation.

Once we hastily picked up some eggs and bacon on our way into town, deciding to shop more thoroughly after a night's rest. The salt shaker reposed on the old kitchen table as we had left it the previous summer, and we prepared to enjoy our first quick meal.

What a shock to discover that no matter how much salt we poured on our eggs, the taste remained unchanged. There is nothing quite so bland and unpalatable as unsalted eggs. Of course, the salt had no taste because months of dampness had stolen its flavor. It was useless—so much sand in a glass shaker. And of course, we threw it away.

All human tissue requires salt. Blood can be replaced to a certain extent by a solution of common salt. Salt helps in making hydrochloric acid which we need to digest our food. An animal or a person with insufficient salt in the body grows feeble and with no salt at all may die.

If you took just the right quantity of table salt and dissolved it in pure water, you would have a salty liquid that scientists call "normal salt solution." They mean that this is the natural kind of water in which every part of the body lives its life. Pure water would injure some of the delicate living tissues, such as the front of the eyeball. Pure water is not natural to the body. Since the eyeballs need to be washed constantly, they are supplied with salt water for the purpose.

Jesus said that Christians were the world's salt. He warned

us that when Christians cease to be Christian, they no longer accomplish their purpose and are good for nothing.

The indwelling Christ creates the normal solution in which we were intended to flourish and grow. Watchman Nee, renowned Chinese pastor and author, refers to the "normal Christian life," pointing out that God through Christ removes the abnormality of life outside himself and restores us to our natural condition. Perhaps recognizing this, we can better understand Paul's frequent reference to "Christ, who is our life."

A quiet little miracle nestled in the book of 2 Kings lauds the restorative power of salt. It was Elisha's first miracle after receiving the double portion of the spirit of Elijah. He healed the impure waters of Jericho with salt in a new bowl. "And the water has remained wholesome to this day, according to the word Elisha had spoken" (2 Kings 2:22). "You are the salt of the earth," Jesus said. You are the salt that brings about healing and wholeness.

In his message to the Colossians, Paul wrote, "Let your conversation [living] be always full of grace, seasoned with salt, so that you may know how to answer everyone" (Col. 4:6). There are no answers to life outside of Christ who is our real life. How sad it is when Christians cease applying the truths of God in their daily living. They no longer bring to the world that which it needs to live and flourish in unity and integrity as God intended. Such "Christians" become useless, tasteless, lifeless, … as useless as the salt we threw away that summer.

Have we lost through sin and neglect the properties of faith that bring wholeness and stability to living? It is a sobering question. The remedy, of course, is Christ indwelling and sustaining as he promised to do if we allow him to season our daily lives with himself.

A Heart at Peace

"Rosalindt! Rosalindt!" Grandma Levin, thick grey braids flopping on her wide chest, clattered across the yard in her long cotton skirts and worn-out slippers, chasing her granddaughter. Her rolling Yiddish tongue whirred in the afternoon air like bumblebees buzzing in the hollyhocks. "Dreenk your milk, dahlingk! Pleeese!"

"A heart at peace gives life to the body, but envy rots the bones." Prov. 14:30

"Dahlingk" was a skinny eight-year-old girl with a crop of wild curls and roguish eyes that always seemed to be laughing at you. Especially when she clanked across her third floor back porch in roller skates at six in the morning. Neighbors clapped their hands over their ears, fuming.

Rosalind was the landlord's daughter around whom everything that ever happened in our neighborhood revolved. She was first to the ice cream truck with a fistful of nickels. Her father brought her presents every night—or so it seemed to my brother and me. We lived on the first floor and had to

share a room and one popsicle a week from the Good Humor man.

It was an often repeated scene—a placating parent with a glass of milk or abandoned supper plate cajoling, pleading. Rosalind received a veritable cordon of indulgent love. Dozens of relatives doted on her.

While we dug a new box for the cat under the porch or hauled soggy bags of garbage out to the alley, Rosalind was being begged to take a few minutes out of her perpetual play time to finish her dinner! My brother and I would wipe the taste of sour grapes from our lips, anticipating that this spoiled kid would grow up rotten. And when she did, maybe we would get the shiny roller skates, the mounds of bright marbles and the shiny bicycle that leaned against the shed door.

We grew up and moved away from the old apartment house, still nursing our envy. Rosalind became a successful business woman, married an almost millionaire and had four black-haired, beautiful sons. In her later years she became the executive administrator of a sling of community centers. Doubtless it takes more than doting relatives and gifts to spoil a child.

What haunts me now, though, is the very real envy that burrowed into my bones. I never became Rosalind's friend because I was too busy being disdainful to think she might be worth knowing. Hunkered down behind the lattice work under the porch, glowering as she tossed her brand new handball against the alley wall, I envied her prosperity. Oh the wasted time and energy that might have brought happy hours of companionship. Instead, my soul was eaten up with envy, spoiling many a gentle spring day or summer night. Nursing bitterness, I could almost feel the rotting of my spiritual bones.

We have now discovered that envy can bring about actual physical as well as emotional and spiritual disease and degeneration. When envy is allowed to grow and fester, bringing along its burgeoning casket of bitterness, it can rob us of peace and good will, and unless dealt with can end in death and destruction. How many of the world's problems would be solved if we could indeed learn to be content with what we have? If we didn't grasp for things that belong to others?

"What causes fights and quarrels among you?" James asks. "Don't they come from your desires that battle within you? You want something but don't get it. You kill and covet, but you cannot have what you want ... You do not have, because you do not ask God" (4:1-2).

Should I have asked God for Rosalind's bicycle? Of course not, but if the lines of communication had been open between God and me, I would never have coveted the landlord's daughter's possessions at all. God shows us what is important and what is not. Through prayer he promises to give us peace of heart in place of decadence. Decadence is from the root word "decay"—the result of death. Death of the soul brought on by placing our confidence in earthly things. A heart at peace—what gift can compare with that?

Apples of Gold

My "country aunt" was my favorite when I was a child. Not that her city counterparts weren't wonderful people whom I loved, but Aunt Dina embodied a kind of natural beauty and order that I found especially attractive.

> *"A word aptly spoken is like apples of gold in settings of silver."*
> Prov. 25:11

The time-honored practice of sitting down to the table at mealtime was a habit she refused to abandon, even in later years when that custom was challenged. She brings to mind a white linen tablecloth starched and ironed to perfection, real cloth napkins carefully folded, and clean, sparkling dinnerware. Aunt Dina's table always featured some centerpiece of grace and beauty.

Her favorite centerpiece was a silver basket-like bowl reserved for special occasions. From one of the several fruit trees on the farm she chose five of the most perfect golden apples, polished them with beeswax and placed them artfully in the bowl. Generally, the top apple retained a pinkish blush and two or three of its own dark green leaves. The effect was one

of perfection, simple elegance.

Whether the writer of Proverbs had such a centerpiece in mind when he wrote his delightful simile, one cannot be sure. Jamieson, Fausset and Brown, in their commentary, indicate that such might be the case, or that the writer might have been alluding to imitations on silver embroidery. The image at once summons the idea of beauty and good taste.

Coupled with its allusion to the apt word, or "the word fitly spoken" as the King James Version renders it, the picture engenders some rather significant insights. What is the poet trying to tell us about the "apt" word? For surely his image is part of his truth.

George Eliot, in *Middlemarch*, wrote, "A poet must have a soul so quick to discern, and so quick to feel ... a soul in which knowledge passes instantaneously into feeling, and feeling flashes back as a new organ of knowledge." In this simile feelings and knowledge link to say something important about the spoken word.

The word is the right word to speak because it is the true word. Silver and gold, to which the writer refers, are both precious metals, costly substances, that must be refined. The purer the gold or silver, the greater the price. The truth is often costly but precious and enduring.

The lyrics to a contemporary secular tune echo with the sad realization that truth is often a rare commodity:

> Honesty is such a lonely word,
>
> Everyone is so untrue.
>
> Honesty is hardly ever heard.
>
> It's mostly what I need from you.

For the person who follows Christ, the true word is the natural word, springing from a heart that has been purified at

great cost. "Surely you desire truth in the inner parts," the psalmist wrote, knowing that the inner part determines the direction of the outward behavior (Ps. 51:6). The apostle urged, "If anyone speaks, he should do it as one speaking the very words of God" (1 Pet. 4:11).

The comparison to "apples of gold in settings of silver" immediately evokes a sense of richness. The word aptly spoken enriches both the one who speaks and the one who hears. How often have we been touched by words that illumine, inspire, impel us. Words can lift us to the heights or bring us to the depths. Paul urged Timothy to "preach the Word; be prepared in season and out of season" (2 Tim. 4:2) in order to bring the truth of the gospel to others. This call is not only for preachers; every Christian gives daily testimony to what is in the heart, and a heart filled with Christ's love will enrich the souls of others.

Because of the impact of language on our lives, there is no such thing as mere rhetoric. Everything we say is important and has consequences. We will be held responsible for our words as well as for our deeds. Careless, ugly, negative words abound in our world. People who cherish truth will heed the injunction of Scripture: "Do not let any unwholesome talk come out of your mouths, but only what is helpful for building others up according to their needs, that it may benefit those who listen" (Eph 4:29).

What rich possibilities for truth, goodness and beauty lie in the province of communication. "The word aptly spoken" is the true word, the word of beauty, the word of enrichment. What a different world we would know if every one did "speak truthfully to his neighbor" (Eph. 4:25). It would be a world as beautiful as "apples of gold in settings of silver."

Pocketful of Holes

My aunt grew several varieties of apples for which she was well known in the western part of Michigan. She sold dozens of apples at the side of the road, and we children would watch for customers as we played beneath the spreading elms of the great farm house. Other apples she canned or made into pies so that through the long winter nutritious fruit was always on hand.

> *"Thou hast multiplied thy merchants above the stars of heaven: the cankerworm spoileth, and fleeth away."*
> Nah. 3:16 KJV

But late one summer, when the fruit should have been spreading a rich harvest aroma across the countryside, there were only a few half-bushels of small, hard apples for sale. Cankerworms had proliferated and done their deadly damage to the young apple trees. Besides killing frosts, the cankerworm is the most feared enemy of the orchard.

The cankerworm is really the larvae of certain moths that attack the leaves of apple, pear and some other trees, entirely

defoliating them when especially abundant. The wingless females crawl up the trunks and lay their eggs on twigs or bark. The larvae appear shortly after the foliage from which, when disturbed, they drop at the ends of silk threads. If they reach the ground they climb the trunk to resume feeding.

The prophet Nahum, in his prophecy against ancient Nineveh where people were consumed with a desire for riches at the cost of their souls, spoke of the cankerworm that spoils and then flees. Because of their idolatry and lust for possessions, the curse of God was upon them. Countries before and since Nineveh have repeated the same error, as many believe is happening in our own day.

Jesus never pronounced judgment on the rich but on those who grew rich at the expense of others, on those who allowed the love of money to consume their best energies and powers, thereby usurping the place of God in their lives. "The love of money is the root of all evil" (1 Tim. 6:10 KJV) and that love will eat away at the good fruit of our souls and destroy us. Like a canker it strips us of our real wealth so that nothing of value remains.

> *Lift up the curtain; for an hour lift up,*
> *The veil that holds you prisoners in this world*
> *Of coins and wires and motor-horns, this world*
> *Of figures and of men who trust in facts*
> *This pitiable, hypocritic world*
> *Where men with blinkered eyes and hobbled feet*
> *Grope down a narrow gorge and call it life.*

Hermann Hagedorn's lines speak to us of the false riches that have blinded so many who live in a world where the price tags have been switched, where ungodly concerns have set us on a course for destruction. The poem speaks too of a longing

to change all that, to lift the dark curtain sin has drawn down upon our senses and to see the light dawning upon life as God intended it.

Only the reality of the Cross can change the downward spiral of our natural inclinations. We have all "gone astray, each of us has turned to his own way" (Isa. 53:6) and our own way is one of destruction—like the cankerworm that eats away at our lives until there is nothing left.

Lord Byron lived a life of pleasure and ease, but when he came to the end of his life he wrote, "The worm, the canker, and grief are mine alone." How sad that souls created in the image of God should be so consumed with the false gods of fame, wealth and pleasure that they are left with nothing but a pocketful of holes.

Martin Luther wrote, "Riches are the least worthy gifts which God can give man, yet men toil for them day and night, and take no rest. Therefore, God frequently gives riches to the foolish people to whom he gives nothing else."

The Lord declares through his prophet in Isaiah 55:2-3: "Why spend money on what is not bread, and your labor on what does not satisfy? Listen, listen to me, and eat what is good, and your soul will delight in the richest of fare. Give ear and come to me, hear me, that your soul may live."

Living Stones

During the week the modest stone structure was a thriving hub of activity—after school programs, adult group meetings, individual interest sessions, Bible classes. On Sundays its gleaming glass doors opened to a colorful variety of parishioners who took their places on scarred but carefully polished pews and prepared for worship.

> *"You also, like living stones, are being built into a spiritual house to be a holy priesthood, offering spiritual sacrifices acceptable to God through Jesus Christ."*
> 1 Pet. 2:5

Now this conclave for counseling, learning and prayer had been reduced by a wrecker's ball to a heap of rubble. Stone upon stone littered the small inner city lot. Already a bottle or two had been tossed among the stones. Here and there discarded newspaper swirled in the debris. So much for our church.

We stood looking at the wreckage, flooded with memory. That northwest corner is where Mrs. Eppworth always sat. She could doze unnoticed in a prism of sunlight from the win-

dow. No one ever had the heart to wake her. She had raised nine children on a limited income augmented by taking in washing. She had also volunteered to take care of the church's small laundry.

The Gonzales family members were regulars in the opposite corner—three boys in white shirts, four girls in dresses that had been bleached and starched into submission. In spite of their continual struggle against poverty, Sunday was a special day. Mr. Gonzales had made with his own hands the wooden cross that once stood behind the pulpit.

Mrs. Pomeroy sat in the middle, always alone. She was a former school teacher who mumbled softly to herself. Perhaps she was lullabying her three babies who had died together in a sudden, devastating fire. Still, her lips framed the words of the hymn, "Praise God from whom all blessings flow."

We cringed to see the crumbled altar. There Old John Grimes used to come every Sunday night to weep out his sorrows against the mahogany rail. We used to argue about whether or not to count him as a seeker since he came every week without fail.

Ruby Lee had been there too. She had sought Jesus one brilliant fall day when the harvest was full and everyone was making plans for the Thanksgiving festival. But Ruby Lee had been left a widow at 31, and her four children sat nervously on the front row, the same row where they'd sat one Sunday before at their daddy's funeral. Bobby Lee had shot himself because his theft of five thousand dollars had been discovered, and the thought of prison had been intolerable.

The altar was indistinguishable amidst the pile of rubble now. But suddenly, as we looked at the demolished church, we realized that these saints we had known and loved were

the real "stones" that made up not just our local church but the Church universal. They were living stones, fragments of the Rock of the ages who could never be destroyed because they were imperishable and precious. Though their physical meeting place was uninhabitable, these believers were secure in the heart of God and in the Church—that beautiful web of human relationship inbreathed with the Spirit of God.

Peter referred to believers as living stones, using for them the same Greek word (*petros*) as for Christ (*petra*). Mrs. Eppworth, Mrs. Pomeroy, the Gonzales family, John Grimes—living stones offering up their sacrifices of love and honor, energized by the Holy Spirit. As we stood on the edge of that chaos of brick and mortar, we prayed that they would remain faithful and that we too would reflect our Savior's holiness.

Kenneth Wuest, Bible scholar and author, writes that God was pleased with Old Testament sacrifices because they spoke of Jesus. He is pleased with the sacrifices of believers because he sees in them a reflection of his Son. How he loves the saints!

"We have relegated the saints to a pink and blue and gold world of plaster statuary that belongs to the past," writes C. Kilmer Myers, a New York City vicar. "We are content to place a statue of Francis of Assisi in the middle of a birdbath and let the whole business of the saints go at that. A real parish is a wondrously beautiful web of human relationship which is given meaning by the man who is himself the meaning of life."

What kind of structure are we building with our lives today? Will it stand the test of time and eternity? "The fire will test the quality of each man's work. If what he has built survives, he will receive his reward" (1 Cor. 3:13-14).

Carry the Light

The aging woman and the little boy sat together on the porch in the dying light of autumn. White haired and wrinkled, the old woman rocked forward in her heavily padded lawn chair. Her cane lay at her feet, poised for service. She pulled an ancient cardigan close about her shoulders and watched the boy through rheumy eyes that smiled for the lips that could not. But no paralysis froze her heart as she warmed to the child's gleeful shouts.

"Let your light shine before men, that they may see your good deeds and praise your Father in heaven."
Matt. 5:16

"What's that?" the boy asked, short arms suspended as he leaned over the porch rail.

In the starless night, a single greenish gleam sparked, disappeared, then lit up another patch of sky.

"Granny, what is that?" the child repeated with wonder-filled eyes.

"Why, those are lightning bugs. Each has its own little light."

The boy bounded off the porch and ran crazily toward the spark. Crying with delight he ran this way, then that, reaching out with his chubby fingers.

"Come, Granny, let's catch a light."

She laughed in the fragrant night. "Granny can't, child. She's too old and tired to run."

The child stopped suddenly and looked back with something of bewildering sadness in his wide blue eyes. Then quickly he bounded off again, calling over his shoulder, "I'll catch a light for you, Granny."

And so he did. After many tries, he captured a bug and brought it back in cupped hands. "For you, Granny. I brought you the light."

Are there not many in our world too old and worn down with the cares of life to "catch a light"—the light that would return youth and zest to their spirits? That would direct them unfailingly to their longed-for destination? The one true light of God?

Light. No other metaphor reveals more sharply the contrast between good and evil, between hope and nihilism, between God's presence and his absence. Light was a favorite symbol of Bible writers, as countless references attest.

God's Word tells us that the light of God shines on every person who enters the world, but that sin has caused spiritual blindness. Sometimes we can perceive just a vague shadow, signifying the presence of light. We may fail to embrace it because we think we are too far away for its rays to touch us. We may shun it because we are afraid what its shining in our lives might mean.

Our dullness, our inability to perceive spiritual truth is what brought Jesus down to move among us. God had sent his

messengers—the prophets, the angels—and even communicated directly with people, though he could not show himself for the brightness of his countenance. Even Moses was instructed to stand in a particular place when God was passing by so that the light did not kill him.

"God, who said, 'Let light shine out of darkness,' made his light shine in our hearts to give us the light of the knowledge of the glory of God in the face of Christ" (2 Cor. 4:6).

There is great mystery here. Mystery and majesty. We can read about the incarnation, write about it, but who can really understand it? God becoming man, yet remaining in every sense God, the Creator, the Governor of the Universe? The incarnation can be experienced, though, even as thousands have discovered. Thousands who have allowed the penetrating rays of God's righteousness to purge the dark places in their lives.

The split veil of the temple at the time of Jesus' crucifixion signified that the barrier between God and mankind had been torn away. People could now look upon Jesus, the express image of God who "lives in unapproachable light" (1 Tim. 6:16), and find, not death but life. Jesus carried the light to us who were unable to grasp it on our own.

Even more surprising is the truth that we ourselves can become light because of his life in us. And that astonishing privilege brings with it a responsibility to carry the light to those who remain in darkness.

The Garment of Praise

Most of us choose our clothes carefully, keeping in mind their distinctive purposes. A garment protects us from the cold winds and in summer helps to keep us cool and comfortable. The clothes we wear cover us—provide for civility and guard our privacy.

> *"The Spirit of the Lord God is upon me ... To give unto them ... the garment of praise for the spirit of heaviness."*
> Isa. 61:1-3 KJV

We also want clothes to be attractive. The multi-billion dollar clothing industry understands that practicality is only one consideration. Beauty is the other side of the coin that determines success or failure.

Our clothes identify our own particular tastes and personalities. "It's just not me," the buyer may lament. If a suit or dress doesn't reflect who we are, we won't buy it, however popular the particular style or color.

Consider praise as a garment. It is the natural result of a heart that loves God. It also reflects who we are, identifying us

as people who honor and revere God. David wrote, "Ye that fear the Lord, praise him" (Ps. 22:23 KJV)! A thankless person has never looked full into the face of the one who provides all things and who loves us beyond all human loving.

The praise of the penitent heart covers our vulnerable souls with the righteousness of God. As we cry out to him, honoring him for who he is and confessing our sins, he hears us. And he exchanges our poor ragged garments for his pure robe of righteousness (1 John 1:9).

Praise adorns the Christian. Again and again we are encouraged to praise God. "Sing joyfully to the Lord you righteous," the psalmist declares, "it is fitting for the upright to praise him" (Ps. 33:1). Praise is not a garment we put on only at certain times, but it is always in style—the perpetual garment of those who fear God.

Prayer and praise are wed in a synchrony of power that offers creative energy for dealing with every human eventuality. It is more than beautiful; it is practical and has a protective quality. Those who love God praise him in times of happiness as well as difficulty. It is a common theme throughout Scripture and interwoven in the experiences of people that praising God often brings actual deliverance.

When the enemy came against Judah, King Jehosaphat prayed, affirming that no one could stand against his mighty God. We read that he "appointed men to sing to the Lord, and to praise him for the splendor of his holiness, as they went out at the head of the army ... As they began to sing and praise, the Lord set ambushes against the men of Ammon and Moab and Mount Seir ... and they were defeated" (2 Chron. 20:21-22).

Sometimes praising God in the midst of trouble brings spiritual deliverance, so that even though we're not removed

from the trouble, our spirits are freed to pass through the fire with joy and honor.

Corrie ten Boom, imprisoned for helping people persecuted by the Nazis, praised God for fleas that infested their prison cells because the guards stayed away, allowing the prisoners to freely pray and draw strength from the Scriptures.

In giving honor and praise to God in the midst of trouble, we are catapulted into his presence. Paul and Silas discovered the secret of praise (Acts 16:25). Even with their feet held fast in the stocks of a Roman prison, their spirits soared with the wild abandon of joy. Their captors were amazed to see such transcendence.

Paul reminds us to give thanks always for all things, because God is greater than our trials, stronger than our severest limitations. "My God shall supply all your need according to his riches in glory by Christ Jesus" (Phil. 4:19 KJV). Our greatest need and joy is to be with him in unity and love.

The lyrics of a contemporary song remind us, "The chains that seem to bind us will fall powerless behind us when we praise the Lord." Praise reminds us that our enduring strength is from the eternal and changeless God who longs for fellowship with us.

God once clothed our first parents with animal skins, providing for their physical needs. He clothes us with the covering of his grace to provide for our eternal spiritual welfare. "Thanks be to God for his indescribable gift" (2 Cor. 9:15)!

The Garment of Love

She came from what my friends considered a "liberal" church. Some of us wondered about the wisdom of including Christians like her in our week-long church conference to study the needs of youth. Even though my children were grown, I realized it was important to minister to young people, so I was giving up a whole week of my time. I hoped that this woman who was to be my roommate might have something to offer to our conference.

> *"Clothe yourselves with compassion, kindness, humility, gentleness and patience."*
> Col. 3:12

She didn't seem to know any of our songs and hymns, and her manner of dress was a bit too worldly for my tastes. But the eyes behind her chic glasses were thoughtful and almost neutralized the effect of the geometrical earrings that dangled gaudily when she spoke. It occurred to me that I might be able to help her to a better understanding of Scripture and smiled at my evangelical approach to my roommate.

Some of her phrases seemed foreign and too passive, and she only nodded politely when I talked about our plan to canvas the neighborhood with gospel tracts.

I expected her to add to some shocking stories I told her about the habits of today's young people, but she hardly had anything to say about them. Maybe it didn't matter that much to her or maybe kids weren't as bad where she came from. Still, there was a strange sadness in her eyes, and she squirmed a little, as though she were quite uncomfortable talking about it.

We went to every workshop, shared notes and lunches in the cafeteria and generally had a good time. I concluded that even though my friend's doctrine lacked something, she at least didn't hog the bathroom we shared.

But something happened when we took a tour of the conference city that really bowled me over. We hit all the scenic spots and later walked downtown, heading for McDonald's and a quick lunch.

A young girl about the age of my youngest came careening down the street. Her skimpy black blouse and leather mini skirt barely covered the essentials. Frizzy hair blossomed over her shoulders, and she walked a little unsteadily, bulging purse banging her bare thigh. Her eyes were sullen, dark and puffy, as though maybe she'd been up all night.

I remember my quick revulsion and sudden feeling of relief as I thought about my own daughter, responsible and active in the corps. How dreadful if this creature coming toward us now with a half-smoked cigarette in her pouting red lips were mine.

I turned to say something to that effect to my roommate whose step faltered just now. I looked at her and saw that same profound sadness in her eyes. Her lips trembled almost

imperceptibly and her words fell on the afternoon air like a benediction.

"There," she whispered, "is someone who really needs a hug."

She lurched forward, as if she would run to the girl and put her arms around her, but the young woman disappeared into a video store, leaving us bewildered in the street.

Stunned recrimination welled up in my heart and a new understanding of the difference between the publican and the penitent in the well-known Bible story. I had seen the poor lost girl and thanked God that my daughter and I were not like that.

My friend saw the same girl and in true love would have embraced her and taken her to her heart. I knew in that moment that God was teaching me about himself. I had looked at my roommate's make-up, earrings and clothes, and judged her on those externals. But she had clothed herself with love, even as the biblical picture teaches. I truly coveted her wardrobe and prayed that I might love lost young people as my friend did.

The Secret Garden

Gardens have figured prominently in our lives since God placed man in Eden and provided for all his needs. In the same garden, Satan ushered in the reign of evil that banished Adam and Eve from Eden and mankind from the secret garden of fellowship for which we were designed. In the Garden of Gethsemane Jesus with great agony prepared to redeem his fallen creation.

"The LORD will guide you always; he will satisfy your needs in a sun-scorched land and will strengthen your frame. You will be like a well-watered garden."
Isa. 58:11

Jesus met Mary in a garden and gave her the good news that the price had been paid, that man could return to an Eden of the soul more beautiful and nourishing than any geographical garden.

Within each of us is a secret garden—a place where we commune with God. When we unlock the gates and allow him to enter, an amazing transformation takes place. Faith flowers where weeds have flourished. His presence in our

parched, unsatisfied, barren lives comes like a cooling drink, and satisfies our desires and our all-consuming need of him. Although his presence is all grace, all gift, the tending of this special garden must ever after be the joint responsibility of the Holy Spirit and our own spirits in concert.

This garden is a place of mystery. It must be conceded immediately that how God communes with us in the secret of our souls is largely mystery. The Apostle Paul speaks of "the glorious riches of this mystery, which is Christ in you, the hope of glory" (Col. 1:27). That the God of the universe who spoke whole worlds into existence desires our company is indeed beyond understanding.

"Now as always, God discloses himself to 'babes' and hides himself in thick darkness from the wise and prudent," writes A.W. Tozer. "We must put away all effort to impress, and come with the guileless candor of childhood. If we do this, without doubt God will quickly respond."

Our metaphorical garden is a place of meeting. Jesus taught his disciples to pray in secret. In his sermon on the mount, Jesus said, "When you pray, go into your room, close the door and pray to your Father, who is unseen. Then your Father, who sees what is done in secret, will reward you" (Matt. 6:6).

We read that he went often to a lonely place, sometimes a long time before it was day, to meet with his Father. It is interesting that he who needed to pray so little prayed so much, and we who need to pray so much pray so little.

In our secret gardens we celebrate a loneliness that is common to us all. It is a loneliness that begs all company but the divine. C.S. Lewis called this estrangement from God "our inconsolable secret." Some have described it as the God-shaped vacuum within us that only he can fill.

Meeting with God in the secret garden of our souls is an invitation to transcend our limitations, to look beyond ourselves and experience the wholeness of God's life in us.

Our secret garden is also a place of might. God gives us the power to love him supremely and to become like him. It is not something that happens automatically when we become Christians; it is taught in communion with him. What we accomplish of good is because of the mystery—God in us. We must tend this mystery well.

In communion with him in the secret place, we learn God's secret wisdom, "a wisdom that has been hidden and that God destined for our glory before time began ... No eye has seen, no ear has heard, no mind has conceived what God has prepared for those who love him—but God has revealed it to us by his Spirit. The Spirit searches all things, even the deep things of God" (1 Cor. 2:7, 9-10).

In his company we learn to love what he loves, to will his will. Wisdom, love, power in temptation—these can come to us only through the Spirit of God. They are imparted to us in personal fellowship with him in the secret place.

The secret garden is a place of mystery, of meeting, of might. Step into the garden where God calls to you in the cool of the day. It is a place of deep spiritual joy, as C. Austin Miles affirms:

> *And he walks with me*
> *and he talks with me,*
> *and he tells me I am his own;*
> *And the joy we share as*
> *we tarry there,*
> *None other has ever known.*

The Single Eye

Once, when traveling from Kansas City to St. Louis by way of Wichita, I realized that my difficulty seeing clearly enough to read road signs and traffic signals could have decidedly negative results. One cannot travel eastward and reach a westward destination! I made an appointment with the optometrist who, after examination, found that my prescription needed strengthening. Not only had my distance vision changed, but my astigmatism had worsened.

> *"The eye is the lamp of the body. If your eyes are good, your whole body will be full of light. But if your eyes are bad, your whole body will be full of darkness. If then the light within you is darkness, how great is that darkness! No one can serve two masters."*
>
> Matt. 6:22-24

An astigmatism is a structural defect of the eye which obstructs rays of light from converging to a point in the retina. Something is out of place or "complicated," resulting in optical defect. He explained that there was basi-

cally a fold in the eye, so that I saw double rather than locating a clear and uncluttered image.

Knowing all about the intricate mechanisms of the parts of our body, Jesus in his illustration used the figure of the eye to enforce the need for singleness of motive, looking right at the object, as opposed to having two ends in view.

With scientific accuracy, Jesus used two distinct words to describe the condition of the eye. The word for "single" is *aplous,* which means "single folded" or "without a fold." Just as the good physical eye sees clearly from a single point of focus, the unswerving desire to serve and please God in everything keeps our character bright, our witness strong.

Such a man was the Apostle Paul, a man of great purpose, who declared in his word and life, "This one thing I do." He determined that his single message would be Christ crucified, and no amount of persecution or peril could deter him from pursuing that goal. Sadly, when we are turned aside by things like desire for power or material gain, our perception is altered, our understanding clouded.

In our Lord's comparison of the eye he uses the word *poneros,* meaning "evil in influence." An evil eye implies obliquity or squinting. Such an eye will see things double rather than single. Spiritually speaking, such an eye exercises an evil influence on the one possessing it and upon others. It is a kind of spiritual astigmatism, and many are afflicted with this kind of seeing.

Jesus said that the eye is the lamp of the body, not the light itself. It is the eye that perceives the light and gives direction for the rest of the body. God made us creatures of the light. In order to apprehend that light correctly, our view must be single, focused on him.

"Love the Lord your God with all your heart and with all your soul and with all your mind" (Matt. 22:37) is the commandment that outlines a singleness of motive and the path the Lord requires. Some think such a directive proves God restrictive, narrow, dictatorial. But knowing us perfectly as he does, God understands that such a commandment is given because it is the only way of life that will result in our happiness. "No one can serve two masters." We cannot love God while loving that which God opposes.

Dio Chrysostom wrote in his *Eleventh Discourse,* "Like men with sore eyes, they find the light painful, while the darkness, which permits them to see nothing, is restful and agreeable." Perhaps he was recalling Jesus' sad pronouncement that "men loved darkness instead of light because their deeds were evil" (John 3:19).

"But whoever lives by the truth comes into the light, so that it may be seen plainly that what he has done has been done through God" (John 3:21). If we would apprehend the light, then our spiritual eye must be without a fold or defect, so that we can see clearly.

The Evergreen Years

Lebanon, with its grand view from the sea, was a frequent source of inspiration for the poets and prophets of Israel. Its two highest peaks were capped with ice on the sultriest days of summer and snow-covered during winter and spring. But Lebanon's glory was its cedar.

Along with pine and oak, the forests of Lebanon yielded cedar for Solomon's temple and other grand edifices. They provided rich resources for shipbuilding as well. It is believed that the whole mountain range of Lebanon, from 3,000 to 7,000 feet altitude, was at one time covered with cedar groves. At the turn of the 20th century, the largest of the trees on the northern summit measured between 30 and 48 feet tall.

"The righteous will ... grow like a cedar of Lebanon; planted in the house of the LORD, they will flourish in the courts of our God. They will still bear fruit in old age, they will stay fresh and green, proclaiming, 'The LORD is upright; he is my Rock'."
Ps. 92:12-15

The psalm writer compares righteous people with the stately and highly regarded cedars which remain fresh and green and fertile in their later years. Ringed about with glorious age, they are still enduring and bountiful. The Christian who walks daily in the precepts of a faith grown sweet and stable over years of experience finds age a blessing, not a drawback.

There have been notable older adults who have gone on to great achievements in their later years. The German author Goethe completed *Faust* when he was in his late 80s. The British statesman Winston Churchill became prime minister of England at the age of 65 and served off and on in that position until the age of 81. Pianist Arthur Rubenstein held public performances at 90. Of course, there are many others, some living right next door to you.

In her recent book *The Fountain of Youth*, Betty Friedan builds on earlier research showing that people who lived extra years were those who were heavily involved in life, active in community and using mental and physical energy with imagination and concern.

What counts in an older person's growth is the urge to work, to use their abilities for a chosen purpose. Friedan points out a role for religious and other community institutions that want to plan wisely for the future: "We must seek the empowerment of age, new roles for people over 60, 70 and 80 in work and business, public and private sectors, church, synagogue and their volunteer cutting edge of the community."

Salvation Army leaders have recognized the tremendous potential of lay and officer personnel in their later years. Some have taken active U.S. appointments in challenging roles. Others have gone to far-flung parts of the world to carry on minis-

tries that will demand every bit of accumulated wisdom and expertise gathered over earlier years. These leaders are like cedars of Lebanon, "still bearing fruit, remaining fresh and green" and proclaiming the gospel of our Lord.

Friedan's expression about the "growth" of older persons fits the ancient analogy well. At every age, we can grow and develop, often at accelerated rates. My own mother used to say in her unique way, "No matter how old I get, God is always older than I am. He's my loving Father and always has something to teach me."

Recently, a 90-year-old Home League member from Miami, Florida wrote of a profound spiritual experience while she was praying. As she thanked God specifically for his help with one of her sons, she sensed an overflowing of love and said to the Lord, "I love you."

"All of my years as a Christian," writes Dorothy Chard, "I had accepted God's love as though I deserved it. But never once had I told him I loved him. I had so much love to give to my friends and family but I had neglected God."

Her confession of love brought peace and a sense of fulfillment. "I knew that God had accepted my love and had been waiting for me to tell him." Whether nine or 90, we can grow as persons, developing more and more our ability to embrace God and others in our lives and experience.

Like cedars fresh and green and fertile, we can bear fruit at any and every age and proclaim the uprightness of our Lord.

The Prayer Closet

"That's a closet?" I asked in disbelief upon being shown through a huge room adjoining the master bedroom of a newly built house. Elegantly decorated and sporting compartments for every known accessory, that closet was big enough to live in.

Undoubtedly, closets of biblical times did not resemble the expansive showroom closet but were small, enclosed rooms beyond the view of the public. The point of Jesus' picture is not that God can hear our prayers better when they're uttered in a cramped space, but that God longs for personal fellowship with us. He invites our intimate communication, the sharing of our deepest selves.

Jesus' words contrast sharply with the prayer of the Pharisee who piously intoned the Lord so that his neighbors would

> *"But when you pray, enter into your closet, and when you have shut your door, pray to your Father who is in secret; and your Father who sees in secret will reward you openly."*
> Matt. 6:6 NKJV

be impressed. Prayer is hardly a thing to be used for personal advantage. And God is someone to be praised, loved and honored, not a ploy in the arsenal of human management techniques.

Beyond the honor and glory due his name is the privilege of intimate fellowship with the Creator. It is not only our joy but the reason we were created—to love God and enjoy him forever! So why is it we fear getting alone with God? Why do we sense a sort of spiritual claustrophobia?

Recently a friend told me his plans to take the rest of the year off to center completely in God, to seek his complete and perfect will for his life. Distractions like magazines and television would be severely limited and the quiet corner his mainstay. There he could not miss the still small voice as he prepared himself for God's direction.

Such a spiritual adventure may seem rather frightening at first. What is it that unnerves us? Beyond the practical concerns of daily bread, might we lose perspective on the human side of things and not be able to re-enter? Might God demand something we aren't prepared to give?

It is, after all, a "dreadful thing to fall into the hands of the living God," as the writer to the Hebrews noted (10:31). The master of the universe who made all things and who holds life and death in his hands is hardly someone to be toyed with. No one is worthy to draw near to him. Yet the same writer who talked of dread and terror in God's presence urges us to "approach the throne of grace with confidence" (4:16) because of Jesus, our great high priest who makes possible our acceptance in the holy of holies, the presence of the living God.

We need not fear being in the closet with God, first of all, because God has made us for such fellowship. He has invited

us in. We don't have to fear close communion with God because Jesus Christ has bridged the terrible gap sin left behind. We are ushered into the Father's presence through the shed blood of the Son who makes us clean.

We need have no fear of God's instruction because his interest is our highest good. Whatever he allows us to pass through in this life, including the surrendering of the self, God cannot be outgiven. Jesus reassured his quaking disciples of this fact. "Which of you, if his son asks for bread, will give him a stone? Or if he asks for a fish, will give him a snake? If you, then ... know how to give good gifts to your children, how much more will your Father in heaven give good gifts to those who ask him!" (Matt. 7:9-11).

It comes down to trust. Do we really trust God to be who he says he is, our loving Father? To do what he says he will do—provide for our needs and give us the desires of our heart? The more we trust him, the more we spend time in close fellowship, the more aware we become that it is in the closet with God that we are most fully alive, most truly human. However broken we may become, it is God who repairs and replaces our little with his abundance.

Madeleine L'Engle wrote this about the closet experience: "In prayer the stilled voice learns to hold its peace, to listen with the heart to silence that is joy, is adoration. The self is shattered, all words torn apart in this strange patterned time of contemplation that in time breaks time, breaks words, breaks me, and then, in silence, leaves me healed and mended."

Simple Extravagance

Sometimes the simplest expression of a compassionate spirit is an extravagance that brings with it a profound gladness and a sense of divine presence. We are not asked to do great things for others, things beyond our power. We're asked to do the simple thing, the thing we can do.

The contemporary epithet, "practice random acts of kindness," implies a certain deliberateness, a conscious decision to "do" something kind. But Jesus emphasized "being," allowing his spirit of kindness to issue forth spontaneously from hearts that beat with his love.

William Barclay relates a story of a missionary in a small African village. From her veranda she taught a group of little girls who had paused in their household duties to learn about Jesus. The missionary was reading our Lord's words about giv-

> *"I tell you the truth, anyone who gives you a cup of water in my name because you belong to Christ will certainly not lose his reward."*
> Mark 9:41

ing a cup of cold water and trying to help the children understand the meaning.

As the sun beat down and the little group grew listless with heat, the missionary's voice droned on. Suddenly a group of tribesmen approached the village, carrying heavy loads and panting with exhaustion. They stopped to rest, taking in their surroundings with wary eyes. The missionary realized they were part of a warring tribe and would not be granted anything by the people of this village.

She watched with amazement as the little girls left the shade of the veranda and retrieved their waiting water pitchers. Placing them on their heads, they shyly and fearfully approached the tired tribesmen who gratefully drank and handed the pitchers back. The little girls then took to their heels and ran back to the missionary. "We have given a thirsty man a drink," they said, "in the name of Jesus."

The little girls had taken the story and the duty literally. Would that all of us understood the simple, salutary teaching of this passage and carried it out. The simple gift given in the name of Christ is lasting and good, and multiplies like the loaves and fishes in a small boy's lunch.

What we do in the name (and spirit) of Jesus becomes sacramental, as Jesus' words in Matthew 25:40 richly illustrate: "Inasmuch as you have done it unto one of the least of these my brothers, you have done it unto me" (NKJV). The late Mother Teresa's life was a continual testament to this truth. She often told her surprised colleagues that when she touched a cup of cold water to the lips of a dying man, it was as though she were giving Christ himself a drink.

This simple extravagance is not something we do once we've determined whether the person in need is deserving of

our attention. It is the outward expression of an inward grace. It issues from a grateful heart, aware of its own desperate need for grace. Everyone in need has a claim on us, because everyone is dear to Christ. And his grace extends to everyone.

The anonymous poet's lines speak of the extravagant nature of God's grace and how it reverberates in the lives of others. The title is a question, "How Long Shall I Give?"

"Go break to the needy sweet charity's bread;
For giving is living," the angel said.
"And must I be giving again and again?"
My peevish and pitiless answer ran.
"Oh, no," said the angel, piercing me through,
"Just give till the Master stops giving to you."

Here Comes the Bridegroom!

Mary met and fell in love with George in a difficult era when the threat of war hung heavy in the English air. They planned a wedding, and Mary purchased her bridal gown and began to dream of the day when the two of them could be together forever.

"Rejoice and be glad and give him glory! For the wedding of the Lamb has come."
Rev. 19:7

But when war was declared, George went off to fight. Disappointed but hopeful, she poured over his regular letters which were filled with loving nuances and promises to return so that they could be married. But one day, the letters ceased, and Mary received the dreaded word from the war department. George was missing in action and presumed dead.

Heartbroken, she clung to his promise, though everything seemed to indicate George would never return. She read and

re-read his letters until she could quote them by heart. Relatives encouraged her to give up hope and face the reality of a life without her beloved George. But she couldn't even think of marrying someone else. She continued to pray and long for the return of her true love.

One day, after reading his letters again, she went to the closet and put on the bridal gown she had purchased before George went away. Through tear-blurred eyes she lamented her loneliness and sorrow. While she was looking in the mirror, a knock sounded on the door. It was her mother informing her that she had a visitor. But she was too preoccupied to leave her room. After a few moments the door opened again, and this time it was George.

With what astonishment and joy she greeted him in her bridal finery! "I thought you were dead," she stammered as she threw her satiny arms around him and kissed him.

"When I left, you told me you would be waiting and that you would be ready," he exclaimed happily. "But I never dreamed you'd be this ready!"

The story is true. But even more stirring is the truth that another bridegroom, our Heavenly Bridegroom, has promised to return to his one true Bride, the Church.

In Scripture, the marriage union is a metaphor for the relationship of Christ to the Church. The final union is described as a wedding feast, a time of rejoicing and great celebration. "The wedding of the Lamb has come, and his Bride has made herself ready. Fine linen, bright and clean, was given her to wear … Then the angel said to me, 'Write: "Blessed are those who are invited to the wedding supper of the Lamb!"'" (Rev. 19:7-9).

In Jesus' parable, the wedding garments were to be pure, without blemish or spot, signifying the righteousness that

clothes the believer when sins are forgiven and the heart is made pure (Matt. 22:1-14).

A bride, ready and waiting for her lover to return. That should describe the Church of Jesus Christ and individual believers today. But it's a picture that more than any other seems clouded on the Christian horizon, as we see Christians today divorcing at the same rate as everyone else in society. Many weddings are shallow, secular observances. This holiest of all estates has fallen into serious disrepair, and littered about the landscape are the broken lives sacrificed to selfishness, greed and indolence.

He promises to return for those who have remained faithful to their vows, those who love and honor him. In a world that scoffs at his commands and disregards his words, only the Holy Spirit can keep us faithful and ready. Paul testified, "I know whom I have believed, and am convinced that he is able to guard what I have entrusted to him for that day" (2 Tim. 1:12).

Have we grown weary waiting? Lost sight of the promise? Hear the words of the Apostle Peter: "The Lord is not slow in keeping his promise ... He is patient with you, not wanting anyone to perish, but everyone to come to repentance." He follows this statement with the sure refrain, "But the day of the Lord *will* come ..." (2 Pet. 3:9-10).

Eternal life, eternal joy. This is what God promises to those who love him, who are faithful and watch for his coming. Are you ready to receive him, dressed in his robes of righteousness? No good deeds of ours could make us ready. Only the spotless Lamb of God, our Savior, makes us ready for his marriage supper.

"The Spirit and the bride say, 'Come!' And let him who hears say, 'Come!' Whoever is thirsty, let him come; and whoever wishes, let him take the free gift of the water of life" (Rev. 22:17).

Comfort

in

Suffering

Engraved on His Hands

A Russian citizen imprisoned by the Nazis during the German occupation of World War II watched his young wife brutalized and killed after soldiers snatched her newborn child from her arms and gave it to a youthful officer whose wife was barren.

> *"Can a mother forget the baby at her breast and have no compassion on the child she has borne? Though she may forget, I will not forget you! See, I have engraved you on the palms of my hands."*
> Isa. 49:15-16

The prisoner gazed for the last time on the tiny lips and wide, bewildered eyes of his only child. Fearful of the days ahead and what cruelties might erode his fragile mental powers, the prisoner did a startling thing. With his knife he carved the name of the child in his right hand. Never would he allow himself to forget the object of his love.

The stirring statement of Isaiah presents one of the most astonishing pictures in all the Bible of God's love for us. Those nail-scarred hands bear the marks of his caring, engraved with our names for time and eternity.

Such a bold cure was necessary for the deep wound mankind had sustained. The entrance of sin into the human heart had estranged mankind from its Creator, leaving all people open for every sort of evil invention and passion. Jeremiah describes the sin of Judah as "written with a pen of iron, and with the point of a diamond: it is graven upon the table of their hearts, and upon the horns of your altars" (17:1 KJV). For so deep a wound, etched in steel with a point made of the hardest known substance, no part-way measure would suffice for the healing. It would cost the ultimate price.

Perhaps it seems ludicrous to imagine the names of every person ever born engraved in two hands. Yet when we consider whose hands we're dealing with, all strangeness disappears. Isaiah reminds us that God "has measured the waters in the hollow of his hand ... with the breadth of his hand marked off the heavens ... and meted out heaven with the span ... held the dust of the earth in a basket ... weighed the mountains on the scales, and the hills in a balance" (40:12). An artist has pictured God sifting the mountains and valleys from one hand to another, as a child sifts sand on a beach. The hands of the almighty God are all sufficient.

There may be times when the eventualities of life with their bitter qualities make us wonder if he has forgotten. Certainly the nation of Israel in Isaiah's day must have wondered if their God had completely turned his back on them. "But I will not forget you," God promised them and promises us. If we wait patiently we will see how he brings his blessings to

pass. The biblical Joseph didn't know that his brothers' betrayal would, years later, result in his whole family being saved from famine, but by remaining upright, Joseph saw the unfolding of God's will in his life.

Brigadier Josef Korbel (R) was imprisoned by the despotic communist government of Czechoslovakia and subjected to unspeakable punishment. He tells of an occasion when he was tied to a barbed wire fence in the dead of winter and left for long hours because he dared to pass a bit of Scripture to a fellow inmate. In the moment of darkest despair, he testifies, he sensed a strange warmth. Looking up, "I saw a pair of beautiful white hands covering my own—hands which bore unmistakably the marks of nail prints."

In those nail-scarred hands God bears the marks of our sin. We recall how after the resurrection Christ came suddenly into a room through no door at all—clad in his glorified body. But still he bore the nail prints in his hands. He will not forget us. Our names are engraved in his hands!

The late General Albert Orsborn penned the chorus as a memorial to this truth:

He cannot forget me,
Though trials beset me.
Forever his promise shall stand.
He cannot forget me
Though trials beset me.
My name's on the palm of his hand.

When Sparrows Fall

The chilling wind of early autumn struck a forlorn note across the empty reaches of the abandoned outdoor shopping mall. This site, once bustling with energetic shoppers, friends exchanging gossip in the little cafe, now lay deserted. Only a pensive early morning walker saw the little bird huddled alone on a flat cement roof.

"I lie awake; I have become like a bird alone on a roof."
Ps. 102:7

The sparrow's grayish brown wings were bunched up around its neck, and the feathers on its head crested in the breeze. If sparrows can shiver, this one shivered from its solitary perch. And something in its bleak, still eye brought a pang to the heart, a too-familiar ache that recalled a moment of deep loneliness.

Loneliness. It comes on a person all unsuspecting. A tune carelessly wafted on air waves sinks deep enough to trigger some long-lost thought or remembrance below the surface. A flower under foot, silently fallen, so quickly broken—like the

heart ... snow on an evergreen falls at a passing touch ... and there it is, that vulnerable, aching sense of aloneness you hadn't noticed before.

A tear starts somewhere from some inner well and creeps a solitary path to the outside. You do not wish to let it come. "Back, back to the hidden spring you came from. No one would understand if you showed yourself." It obeys. But that melancholy thing will not obey—not for long, and not for reason. It is its own reason, a bubbling spring only delicately contained.

No one alive has escaped this terribly human sense. Such a poignant moment came for the psalmist as he uttered his prayer of the afflicted man. He is fainting; he pours out his heart to God. "I have become like a bird [KJV says, "a sparrow"] alone on a roof." In the same psalm, the poet continues his lament. The afflicted man is "like a desert owl ... like an owl among the ruins" (102:6).

The sparrow seems to be used throughout Scripture to illustrate vulnerability and perhaps a sense of insignificance. Maybe those two feelings go together to bring about in us that sense of being alone—alone and unimportant. When Jesus speaks of the sparrow falling from its nest with the full knowledge and concern of the Heavenly Father, he seems to be telling us that even the weakest, smallest creature that belongs to him is important in his sight. When he speaks of the two sparrows sold for a penny, reminding us that we are worth more than many sparrows, he affirms that what may seem insignificant in the eyes of the world is of great value to God (Matt. 10:29-31).

The Bible contrasts the vulnerability of man with the limitless provision of God. "Even the sparrow has found a home ... a place near your altar," writes the poet in Psalm 84:3. At home

with God. No wonder when we are apart from him we are so utterly desolate and without hope. For he is our home. When God gave his promise of continued love and provision for Israel in Hosea 11:11, he said, "They will come trembling like birds from Egypt, like doves from Assyria. I will settle them in their homes."

Perhaps we don't like to think of ourselves as weak and vulnerable. Our age asserts its human superiority and urges us to channel the hidden power within to bring us to greater accomplishments. But we embrace a foolish ghost-lover when we begin to believe that "man is the measure of all things." Better to remember that, however humbling it sounds, "men are like grass"—today alive and green, tomorrow withered and brown, or like a sparrow alone on a roof. But remember too that "even the sparrow has found a home, ..." a place near his altar, indeed nearer—a place in the very heart of God.

How strengthening to know we have aligned ourselves with absolute power, with eternal life, with the creator and governor of all things. Perhaps Arthur Hugh Clough had this in mind when he wrote his poem of faith:

> *It fortifies my soul to know*
> *That, though I perish, Truth is so:*
> *That, howso'er I stray and range,*
> *Whate'er I do, thou dost not change.*
> *I steadier step when I recall*
> *That, if I slip, thou dost not fall.*
> *—Revell,* Treasury of Christian Poetry

The Sea of Glass and Fire

The Revelation of John contains power-ful and evocative imagery. One reads it with a mix of fear and appreciation and sometimes with a degree of bewilder-ment. A certain amount of disagree-ment exists as to the precise mean-ings of many of its awesome pictures. It is not the purpose here to draw elaborate analogies between this prophecy and any particular event in the world's history but rather to glean from it a practical and thoroughly biblical concept.

> *"And I saw what looked like a sea of glass mixed with fire and, standing beside the sea, those who had been victorious over the beast and his image and over the number of his name."*
>
> Rev. 15:2

In a highly figurative way, this passage refers to all moral contests. It speaks of the great struggle with suffering and wick-

edness of which, in our innermost beings, we early become aware.

Some scholars have given the beast very personal interpretations. In its largest sense, the *beast* means all that is beastly, low—all that keeps us from God. And "they who have been victorious over the beast" are those who have come out of trial pure, who out of much tribulation enter the kingdom of heaven.

They walk upon "a sea of glass, mingled with fire." The sea of glass could very well describe rest or repose. When we want to describe serenity or repose, we often use the simile "as smooth as a sea of glass." But what can the mingling of the fire signify?

Throughout the Bible fire typifies active trial of every sort. Fire, with its quick, eager, searching nature, tests all things, consumes evil, purifies pain. "The fire will test the quality of each man's work," we read in 1 Corinthians 3:13.

The sea of glass mingled with fire—repose mingled with struggle—gives us a picture of the permanent value of trial. When we conquer our adversaries and difficulties, it is not as if we had never encountered them. These difficulties are not only events in our past history, but also elements in our present character. Our victories are colored with hard struggle. Our sea of glass is always mingled with fire.

Joni Eareckson Tada, a paraplegic for three decades, has brought the fragrance of Christ into many lives through her powerful demonstration of victory in the face of great tragedy. Recently she said in a *War Cry* interview, "The same anchors hold me now that held me 30 years ago when I was coming out of depression and despair—despair that God permits what he hates to accomplish something he loves." Her suffering has been overturned and become the sweet savor of triumph through Christ.

"The life that has been overturned ... by the strong hand of God, filled with the deep revolutionary forces of suffering, and purified by the strong fires of temptation, keeps its long discipline forever, and roots in that discipline the deepest growths of the most sunny and luxuriant spiritual life that it is ever able to attain" (Philips Brooks in *Classic Sermons on Suffering*).

God never wastes anything. This truth we cannot miss as we study the Scriptures and the lives of saints, and as we reflect upon our own experiences. Even our tears, the psalmist reminds us, are stored in God's "bottle." For what purpose? That we are not always given to know.

When the Lord heals and frees us, we are like the man at Capernaum, carrying our beds on our backs, trophies of our conquered palsy. Unless we have the mingling of the fire, the glassy sea will not bear our weight. It will crack or break. Our troubles become our teachers if we are willing to learn. Martin Luther wrote, "My temptations have been my masters in divinity."

"It takes a world with trouble in it to train men for their high calling as sons of God, and to carve upon the soul the lineaments of the face of Christ," wrote James S. Stewart, Scottish pastor and professor.

Our Lord speaks in our suffering with more clarity than at any other time. Often we tremble at this Voice and wonder if we can bear it. But if we listen closely, we will hear his patient assurance of help in our struggle. The fire is necessary if we are to walk the sea of glass.

> *When, through the deep waters I call thee to go,*
> *The rivers of sorrow shall not overflow,*

For I will be with thee, thy troubles to bless,
and sanctify to thee thy deepest distress.

When through fiery trials, thy pathway shall lie,
My grace, all sufficient, shall be thy supply,
The flame shall not hurt thee, I only design
Thy dross to consume, and thy gold to refine.

—The Salvation Army Songbook

Tears in a Bottle

Some Eastern nations observe the custom of bottling mourners' tears as a memorial to the deceased loved one. If it was not a custom in the psalmist's own country, he was at least aware of it and used it to enlist our attention to human sorrow and God's concern with it.

> *"Thou tellest my wanderings; put thou my tears into thy bottle: are they not in thy book?"*
> Ps. 56:8 KJV

Philip Yancey voices our often repeated question in his book, *Where Is God When It Hurts?* It seems at times that there is no meaning to the suffering through which we must pass. It appears senseless, wasted, random. Like Job, we think if we could ascertain the "why" we could suffer bravely and well. Yancey doesn't give the answer to "why?" And God did not give reasons in response to Job's query. Instead, the focus is on God himself, revealing God involved in human suffering, thus giving the ultimate attention of his love and providence.

Not only did God metaphorically place our tears in his bottle,

but he became the divine substance of all our sorrows and was poured out as the ultimate sacrifice to effect the healing of every broken and sorrowful heart. In the economy of God, nothing is wasted. He bestows no gift upon mankind that does not hold significance. There is no gift withheld but for divine and perfect knowledge that restricts it for our good.

Does suffering have meaning? Suffering conveys our human nature, defining our experience. We would destroy ourselves were it not for the gift of pain, for it warns the body of impending danger. Pain forces us to withdraw our fingers from a hot stove, thus avoiding the loss of mobility and usefulness. Suffering shows that we live in an imperfect world in which sin has placed its ugly stamp on the just and the unjust ... sin which distorts pain out of all proportion and corrupts this gift of God to humans.

Our suffering reveals the need of comfort and teaches us to give comfort to others. It aids our understanding of the sacrifice of one who did not need to become involved but who chose to because the persons suffering are of great value to him. Suffering leads to deeper understanding of joy and healing. It embraces so much more than one can calculate. We shall have to wait until his new kingdom of love and peace is ushered in to appreciate what it has cost in terms of divine and human suffering to bring about our ultimate good.

William Cowper has lyricized this truth for us:

Ye fearful saints, fresh courage take.

The clouds ye so much dread

are big with mercy and will break

with blessings on your head.

The idea contained in Cowper's lines is not far in design from the psalmist's expression. Both declare that God thinks

enough of our human tears to preserve them with the intent of turning them from bane into blessing. In the experiences of many Christians, God has used just those wrenching, hurting, weeping experiences to become the very means by which the greatest joy is generated.

Do you sometimes think that God does not hear? That all our pain and tears are wasted? Is God some kind of sadist? Or is he, as Scripture says, the Physician? "He is as grieved by the world's trauma as you are," says Philip Yancey. "His only Son died here. But he has promised to set things right. Nothing simply disappears."

Nothing simply disappears—not even our tears. God cares about our tears. Indeed he became the divine substance of all sorrow, was pierced, broken and poured out that we might be whole.

> *The wounded surgeon plies the steel*
> *That questions the distempered part;*
> *Beneath the bleeding hands we feel*
> *The sharp compassion of the healer's art*
> *Resolving the enigma of the fever chart.*
>
> —*T.S. Eliot,* Collected Poems 1904-1962

Bruised Reeds and Smoldering Wicks

Candles have long been associated with celebration and worship. Long tapers, elegant pillars, small votive lights, even miniature birthday candles remain in popular demand for a variety of occasions. Once purely utilitarian, candles continue to fill our homes with their warmth, fragrance and light.

> *"A bruised reed he will not break, and a smoldering wick he will not snuff out."*
> Matt. 12:20

The earliest method of candlemaking involved dipping the wick, usually made of flax or cotton fibers, into melted wax or fat, then removing it to cool and solidify in the air. The candle was built up to the required thickness by successive dippings. Most candles used today are molded by machine, though tapers are still made by dipping.

Candles lend an aura, an ambience, and sometimes kindle a longing in our memories, a nostalgic awareness of some-

thing beyond our ken. And when we extinguish them, there follows a slight resistance, a flickering, then a single glowing red spark. What once burned with passion, cheering our rooms and hearts, becomes nothing more than a smoking wick.

Perhaps you have felt akin to the simple metaphor Jesus quoted from the prophet Isaiah. Some relationship that once burned brightly has cooled, leaving you with only a yearning sense of loss. A marriage, once bright with promise, has ended in smoldering disappointment, brokenness and pain. Rejection or personal failure stings your eyes like smoke blown in the wind.

Who has not been bruised by the blows of an often unkind, sometimes torrential world? By the blistering heat and cruel winds that tear and blanch and beat? Like reeds along the river bank, once tall, supple, and green but now bruised, brown, unsightly. Something to be passed over by a gatherer of spring bouquets, pushed aside or thoughtlessly cut down. Bruised, useless.

Who has not fallen victim in some measure to the powers that invade our fallen world? Scripture teaches, "All have sinned and fall short of God's glory" (Rom. 3:23). To all of us beaten down and discouraged, the Son of God comes not with a rod to break us but with healing in his wings.

Long before The Salvation Army adopted the slogan "A man may be down but he's never out," Jesus authored and demonstrated it. He knows well how evil can trip up a person, beat him or cause him to beat himself and cast him headlong to the wolves. A person in such a condition always draws from Jesus the compassionate word, the tender glance, the healing touch.

Consider the thief on the cross, brought to the most shame-

ful and dreaded position a man could imagine. Broken, bleeding, enduring the jeers and jabs of a vengeful crowd, he knew he deserved to die. To this one Jesus lovingly turned and granted a place in his kingdom. "Today, you shall be with me in paradise."

The woman caught in the act of adultery drew stones from a pitiless mob but from Jesus love—a power strong enough to end her sinning and give her hope again. He could do for her what no ordinary person could. Jesus is radically unlike anyone else who has ever lived. The difference, in Charles Williams' phrase, is the difference between "one who is an example of living and one who is the life itself."

This is what Jesus offers—life and with it purpose and possibility. To a world filled with smoking wicks and bruised reeds, Jesus offers hope. Hope that a bruised marriage can once again be healed, that a broken friendship can be restored, that love can glow where once resentment and cold detachment smoldered. That personal failure can be conquered through faith in the Jesus who believes in us long before we come to believe in him.

Elizabeth Barret Browning had a domineering father who led Elizabeth's sensitive spirit to move inward. Shy, weak and full of fear, she was destined to a life of failure. At 40 she met Robert Browning who didn't see a middle-aged sickly woman but a beautiful, loving spirit ready to move from a dark room into the light. At 43 she bore a healthy child and went on to delight the world with soaring poetry that continues to speak. Robert Browning believed in Elizabeth, loved her and thereby empowered her.

"This is the victory that has overcome the world, even our faith" (1 John 5:4). Faith in the one who has set in motion the

healing of the world and will one day usher in a glorious new kingdom where bruised reeds and smoldering wicks will be only poor metaphors half remembered.

So Great a Cloud

Imagine you're at the starting line in the most important race in history. You're in a great stadium filled with Olympic athletes watching your performance!

That's the image the writer to the Hebrews presents to portray the Christian's journey. We're not wayfarers strolling leisurely along the byways of life or tourists returning each night to a fixed place, but we're contenders always on the move. We're heading for a particular goal—Christ himself, his presence, his likeness. It's the most important race ever run.

"Therefore, since we are surrounded by such a great cloud of witnesses, let us throw off everything that hinders and the sin that so easily entangles, and let us run with perseverance the race marked out for us."
Heb. 12:1

Not only is Christ the goal of our journey, he is also the companion of our way and our example. "For the joy set before him [he] endured the cross, scorning its shame, and sat

down at the right hand of the throne of God" (Heb. 12:2). There, having reached his goal, he waits to welcome us when we reach the end.

Essential to the image is this great "cloud of witnesses." Our race is run in the gaze of the heroes of the faith who lived and suffered and died in their day and generation. Imagine Abraham, Noah and Rahab peering down through the corridors of time to watch our progress. Gideon, Joshua, Deborah and the prophets monitor the scene. They're watching, but what is more, they're cheering us on.

But how do we "catch a cloud and pin it down?" There's a sort of mystical quality about this cloud. How do we relate to people like Isaiah whom Jewish legend tells us was sawn asunder with a wooden saw when he refused to take part in his country's idolatry? Or Jeremiah stoned to death by his own fellow countrymen? Or more modern heroes who endured punishments so graphically cruel and insidious that our modern horror movies pale in comparison?

Even now as we approach the 21st century, our world is experiencing a new wave of persecution that astonishes our modern tolerant sensibilities. Christians in China, Africa and other parts of the world are being imprisoned, beaten and murdered for no other reason than that they pledge allegiance to Jesus Christ.

When we try to match up our faith with that of people like St. Paul, Alexandr Solzenhitsyn, Dietrich Bonhoeffer or the suffering saints of today, the connection seems as ethereal and elusive as a cloud. This cloud quality has a distancing effect. After all, we think, we're not saints like they are. We're ordinary people living in a privileged nation with life comforts so many and so available as to make suffering for our faith

seem utterly archaic. The distance remains even though we know that right now there are Christians suffering and dying because they remain true to their beliefs. Could we be as strong under that kind of duress?

Were those Christians who persevered to the end saints or were they ordinary people like us? What would we say if asked to recant our faith? When we ask ourselves that question, we sometimes tremble. We're not sure we could steadfastly hold to our convictions against such temptation. Actually, God tells us not to prepare ahead of time what we will say on an occasion like that.

Jesus, in his warnings and encouragements to his disciples, said, "When you are brought before synagogues, rulers and authorities, do not worry about how you will defend yourselves or what you will say, for the Holy Spirit will teach you at that time what you should say" (Luke 12:11-12).

Our task is to remain faithful now, in the little or large struggles of our lives and to commit ourselves to the faith. Peter, James, Mary and Joanna were ordinary people like us who possessed extraordinary faith. But it wasn't something they could take credit for. Faith is a gift of God. And God gives good gifts. It is up to us to accept his gift of faith, to use it, guard it, develop it so that in the end we will remain true to it.

That, I believe, is all that the great heroes of our faith did. But it was enough. It was enough to see them through the most dramatic conflict, the deepest suffering, even death. And now they watch, this great cloud of witnesses, cheering us on. What a mighty applause that must be.

The Costly Cure

Jeremiah lived during a time of interna-
tional turbulence that finally destroyed his
tiny nation of Judah. During his minis-
try, Assyria, which had oppressed Judah
for a hundred years, was replaced by
Babylon, the new superpower. Several
rebellions ended in exile and the na-
tional oblivion of Judah.

> *"Is there no
> balm in Gilead? Is
> there no physician
> there? Why then is
> there no healing for
> the wound of my
> people?"*
> Jer. 8:22

It was Jeremiah's task to confront a
people who seemed to become more insanely
confident as the peril grew. They thought God would not let
Judah and Jerusalem fall because they possessed the Temple
and the one true religion. Jeremiah had to tell them that pos-
session of the true religion made them more liable to destruc-
tion, not less, if they didn't live out their religion's precepts.

Jeremiah prophesied the terrible devastation that would
come as a result of his people's gross sin—their idolatry and
the sacrifice of their sons and daughters. These children were

thrown into a firepit called Tophet located in the Valley of Hinnom which curves around the west and south side of Jerusalem. Jesus referred to this place as "hell fire" in Matthew's Gospel. Jeremiah prophesied that where Judah had sacrificed their children, their own corpses would be scattered about after the destruction of the city. (To be left unburied was a horrible fate for the ancient Israelite.)

Jeremiah's announcements of judgment on the people who refused to listen to him were not characterized by vindictiveness, but by great anguish. "Since my people are crushed, I am crushed; I mourn, and horror grips me" (8:21).

At this point in his lament for Judah, Jeremiah refers to a healing ointment known to have curative powers. The balm was extracted from a tree and applied to a wound. Josephus refers to it as balsam that was brought into Judea first from Arabia by the queen of Sheba in Solomon's time. Pliny refers to opobalsamum or bochart, the resin drawn from the terebinth tree. The substance abounded in Gilead, east of Jordan, where in consequence many physicians established themselves.

But what palliative will lessen our national pain? It is still sin that devastates a land and its people. Our country, no less than Judah, stands in danger of God's judgment on its sins, its refusal to honor God and his righteous commands. Sons and daughters are still sacrificed on altars of convenience and passion. People today call upon their various gods to deliver them, but neither money nor science nor psychology nor any other substitute for our souls' allegiance will bring the peace and wholeness we so desperately seek.

An African-American spiritual employs Jeremiah's image in a song that beautifully personifies the balm in Gilead as the

Holy Spirit who brings healing through God's gift of grace:

There is a balm in Gilead to make the wounded whole.

There is a balm in Gilead to heal the sin-sick soul.

The people of Judah were sin-sick as many are today who have not been touched with the healing grace of God. Only grace can save us who have been wounded in a world of ungrace and who, caught up in it, continually wound others. Jesus said in Luke 4:18-19, "The Spirit of the Lord is on me, because he has anointed me to preach good news to the poor. He has sent me to proclaim freedom for the prisoners and recovery of sight for the blind, to release the oppressed, to proclaim the year of the Lord's favor."

Yes, there is a balm in Gilead and there is a balm in America for the healing of our nation, for the healing of our sin-sick souls. It was poured out at Calvary 2,000 years ago and still flows for our salvation.

"The world runs by ungrace," writes Philip Yancey. "Everything depends on what I do. Jesus' kingdom calls us to another way, one that depends not on our performance but on his. He has already earned for us the costly victory of God's acceptance." Now it is up to us to claim our healing.

It is still the Lord who "forgives all your sins and heals all your diseases, who redeems your life from the pit and crowns you with love and compassion" (Ps. 103:3). Reach out today and take the gift of grace held out to you. It is the most costly cure in the world but it is available to all and it is given in grace. Believe in him and let him heal your sin-sickness and bring you spiritual wholeness and joy.

A Glimpse of Joy

Recently I meandered through a city park with an idyllic little pond where ducks and swans swept along quiet currents. Unafraid, they teased crumbs from old men and lovers and shared their habitat with children lured from their video games to the old enchantment of the water.

> *"My days are swifter than a runner; they fly away without a glimpse of joy. They skim past like boats of papyrus ..."*
> Job 9:25-26

A little boy of five or six sat on a grassy bank, dabbling his fingers in the pond. The sun dazzled on a small white boat that he guided eagerly into the stream. It was reminiscent of an earlier age or perhaps the corporate childhood of all the ages when little boys made paper boats and sent them sailing in puffs of wind.

Did Job have such a thought as he waited in the pale agony of his loneliness, after he had lost everything, including his health? Had he as a little boy fashioned a paper boat and sent it sailing on some ancient river? Perhaps he recalled how it

had skimmed away, caught in a gleam of sunlight, propelled with amazing speed and fragility.

So had his days passed, and in his extraordinary distress he contemplated the departed moments of his life. The psalmist may have had a similar thought when he wrote: "As for man, his days are like grass, he flourishes like a flower of the field; the wind blows over it and it is gone, and its place remembers it no more" (Ps. 103:15-16).

Sobering words that have occupied many minds. Peasants and poets everlastingly ponder the mystery of time, marvelling how quickly their days have vanished, how inexorably they seem propelled to the end of life. One poet has written with ominous portent:

The force that through the green fuse
drives the flower
drives my green age.

But we recognize the truth, of course, and when we do, we determine to make the most of our time—to catch the present. "Catch it if you can," Annie Dillard wrote in her award-winning *Pilgrim at Tinker Creek*. "The present is an invisible electron; its lightning path traced faintly on a blackened screen is fleet, and fleeing, and gone."

At first, we who are uncomfortable with Job's bleak honesty might pass over his reference to days passing "without a glimpse of joy." Surely he didn't mean it. He was just so sad, so distressed. But I think he did mean it—exactly that.

Job never received answers to his "whys" in all his searching before God. He was always brought back full circle to the "who," and eventually had his glimpse of joy. Perhaps if we capitalized the "j" in "Joy," the meaning might be clearer. For when Job saw God with that unmistakable vision of the spirit,

there were no more questions.

If it's true that our life is all about seeking—a quest, what is great enough to be the object of that seeking? Truth? Beauty? Joy? Love? These are but pale personifications of the shining Reality! We are looking for God in the translucent gossamer of a butterfly's wing, in the sun-silvered spray of ocean foam, in the impenetrable wrinkles of an ancient tree, in a baby's petal-soft face.

David's lament over the fleeting experience of his days is quickly followed with this resounding affirmation in Psalm 103:17-18: "But from everlasting to everlasting the LORD's love is with those who fear him, and his righteousness with their children's children—with those who keep his covenant and remember to obey his precepts."

What tragedy if we should pass so fleetingly through this life and miss the glimpse of joy. Jeremiah gives us the Lord's assurance that "you will seek me and find me when you seek me with all your heart. I will be found by you."

Throughout history God has been trying to make himself known to us. All of nature testifies of him. The prophets spoke his messages in such variety that even the most obtuse could understand at least one rendition. Then to be sure we did not miss him, he came himself—entering our limited world, walking with us all the way to death, and beyond, then sealing with his Spirit our consciousness for all time.

Are our days like paper sailboats in the wind? Perhaps … but sailboats bound for joy and "trailing clouds of glory."

The Solitary Place

The last hope for renewal of Indian summer had died on the backyard fence. Squirrels and birds kept solitary vigil while long mid-afternoon shadows confirmed the winter solstice, that deepest, darkest heart of winter. But everywhere people seemed charmed by a mysterious rising hope and wondered if it would snow by Christmas.

> *"The wilderness and the solitary place shall be glad for them; and the desert shall rejoice, and blossom as the rose."*
> Isa. 35:1 KJV

It would be my first holiday alone, following the death of my husband. "It will be a difficult Christmas," my friends told me solemnly, causing me to approach Advent with a kind of dread. Someone even reminded me that there are more suicides during the weeks surrounding Christmas than at any other time of the year.

My friends were right, of course. There would be no secretive plotting of the children's gifts, no laughing over the tree that looked so perfect in the lot and so wretched in our living

room. And on quiet evenings when the fire used to synchronize the tangled moments of a hectic day, I would know only the deafening roar of my solitary place.

Christmas seems to have been a solitary business for those involved in the first Advent. Consider Mary, alone with the poignant knowledge that her child, born of God, was destined to die. Consider the wise men, alone as they trudged across the desert, without affirmation and old Simeon, alone as he languished in the Temple, yearning to see the Lord's Christ before he died.

Each awaited Christmas in solitude of heart—the solitary place that begs all company but Christ. Each worshipped him, accepting the miracle of the Incarnation, of God becoming flesh.

Martin Luther wrote, "Let him who cannot be alone beware of community. Alone you stood before God when he called you; alone you ... had to struggle and pray; and alone you will die and give an account to God."

If we attempt to substitute the so-called goodwill of Christmas, its mingled tradition and merriment, for the presence of God, we will only be more savagely aware of the emptiness of life. For without him life is a desert and joy a series of mirages.

Is the "God-hope," flickering in the soul of every person, fanned at Christmas, as though the Creator would try once more to reach us? "As though God were making his appeal ... Be reconciled to God" (2 Cor. 5:20)? Is this longing for God what Virginia Stem Owens meant when she wrote in *Wind River Winter*, "I long for a clean Christmas with no gift but God"?

Why are the lonely more lonely at Christmas? Why are the despairing more desperate? Can it be that Christmas makes us more aware of our poverty without God? That all the merri-

ment of friends and family, all the tinselled accompaniments fail to fill the void and leave us lonelier still? When holidays end, even though touched with human warmth, and no splendor has occurred in the soul, the end seems worse than the beginning.

"The wilderness and the solitary place shall be glad ... and the desert shall rejoice, and blossom as the rose" (Isa. 35:1). He will take the wilderness (the untamed heart ruined by sin) and the solitary place (void of his presence) and leave in the wake of Christmas a blossoming garden.

No place is so solitary that God cannot fill it with himself. Indeed, we come in our solitude and discover in him everything. When Christmas is fully come to the heart, we find ourselves full and rich and ready to share in joyful community.

Harps on Willow Trees

It is a sad chapter in the history of the Jewish nation. The Israelites are taken captive by their enemies and brought to Babylon. As they enter the strange land, so far from their Jerusalem home, their agony deepens. We can picture them trudging along the water's edge where willows bend as though in kindred sorrow. They look back, straining to glimpse their beloved homeland. Remember the green hills of Judea! The thriving cities with their color and dance and music. Remember the quiet family dwellings where loved ones ate and made love and slept the sleep of the blessed. Memories now. Sad, sweet memories.

> *"By the rivers of Babylon, there we sat down, yea, we wept when we remembered Zion. We hanged our harps upon the willows in the midst thereof ... How shall we sing the LORD's song in a strange land?"*
> Ps. 137:1-2, 4 KJV

They cannot bear to move their fingers over the strings of their instruments which they carry with them into captivity.

There can be no music now. It may be literally true that they hung their harps on the willow trees, but there can be no doubt that what is conveyed by the writer in this picture is sadness so great they found themselves unable to rejoice or give thanks. "How shall we sing the Lord's song in a strange land?" they asked.

For the Christian, this world is not home. We're only passing through on our way to that place for which our souls yearn. Can we sing praises to God in a strange land? We sing, not because of our situation or circumstances, but because God is with us. The beloved one whose company makes the darkest valley bearable becomes the theme of our song.

"The LORD is my shepherd ... Though I walk through the valley of the shadow of death, I will fear no evil, for thou art with me" (Ps. 23:1, 4 KJV). So the psalmist wrote, and so Christians throughout the ages have whispered from the depths of quaking hearts made strong in the awareness of Emmanuel.

What can be more foreign to the human spirit created in God's image than death? It is not for death that we have been created but for life. God is the source of all living. He is Life. We, born of his Spirit, have the promise of eternal life. Yet, in this land made foreign by sin, death is all around us ... death of relationships, death of dreams. How can we sing in this foreign land of death?

Joni Eareckson Tada, paralyzed for the past 30 years, writes that when she is discouraged, when frustrated with her immobility and inability to do the small tasks that everyone takes for granted, she finds joy in "singing to Jesus." Determining not to doubt in the darkness what she has learned in the light, Joni sings, "I must tell Jesus all of my troubles. I cannot bear these burdens alone." And she finds that God is able, that in-

deed "Jesus can help us. Jesus alone."

Job found his song in the life of God himself. "I know that my Redeemer lives, and that in the end he will stand upon the earth ... And ... I will see God" (Job 19:25-26). So many have found that just when they feel most uncomfortable, weak and far from home their song is clearest and most beautiful. George MacDonald has wisely written: "How often we look upon God as our last and feeblest resource. We go to him because we have nowhere else to go. And then we learn that the storms of life have driven us, not upon the rocks, but into the desired haven."

Do you find yourself in a position outside your comfort zone? Do you cringe under a load of misunderstanding or oppression? Have you hung your harp on the nearest willow along the river of your discomfort? You can sing the Lord's song in a strange land. He will guide your fingers over the strings and be himself your music. Edwin Markham's inspired lines remind us of the truth that space is made for joy by the stretching lines of sorrow.

> *Defeat may serve as well as victory*
> *To shake the soul and let the glory out.*
> *When the great oak is straining in the wind,*
> *the boughs drink in new beauty, and the trunk*
> *Sends down a deeper root on the windward side.*
> *Only the soul that knows the mighty grief*
> *Can know the mighty rapture. Sorrows come*
> *To stretch out spaces in the heart for joy.*

One Last Sigh

We readily relate to this feeling—we who watch our todays nipping at the heels of our tomorrows like so many yammering hounds. A moment ago we were children, itching to grow up and experience life. Suddenly we are old and wondering what has happened to all those years. No wonder we sigh.

> *"We finish our years like a sigh."*
> Ps. 90:9
> NKJV

The expression in Psalm 90 is part of a prayer attributed to Moses. The mood is one of deep awe in which the writer sets the majesty and eternal nature of God ("from everlasting to everlasting you are God") against the ephemeral quality of human life. Our days, he writes, "… quickly pass, and we fly away" (v. 10). The writer ends with the earnest plea that his short days will have meant something in the eternal scheme of things. "Establish the work of our hands for us—yes, establish the work of our hands" (v. 17).

A sigh can denote weariness, sadness or longing. Sometimes it means we are satisfied or overwhelmed. Even a tree

sighs in the wind when it is bent and pulled and pierced through. Whatever it means, a sigh comes from deep within and expresses the inexpressible.

A child sighs in wonder when it cannot explain why it wonders. A young woman sighs when love has pierced her through and she hurts but loves the hurt. A young man sighs when he wonders at himself, when he aches with life and cannot do all the things his bones stretch to do.

An old woman sighs when she looks back at all her fingers have touched or held or let go. She watches the pictures of her life and sees a shape emerge—and she sighs, unable to reveal the picture to another living soul. An old man sighs as he picks up the rope of his well-weathered boat and moors her for the hundredth time. So many ports, storms, sailors and sailors' women. And the seas roll on and on in spite of it all, and he is yet alive to sail the inexplicable seas.

For all we know about life and living, it remains a mystery in so many ways. We know with the eyes of faith that we've been placed here, not as a result of some cosmic accident, but as participants in an adventure designed by a loving, purposeful God.

Solomon concluded that the whole duty of man is to "fear God and keep his commandments" (Eccl. 12:13). In our lives we will marvel at many things. We will learn some things. Much will remain inexplicable. But he who has promised to "guide you into all truth" (John 16:13) can be trusted to teach us what we need to know.

He will show us himself. From the dawn of history, God has been trying to break through and show us who he is. Nature, prophets, angels, scribes—all testify of him. But none has spoken so eloquently as Jesus, "the exact representation"

of God (Heb. 1:3). He came as a light dawning upon us:

> *The prophets spoke,*
> *Their holy fingers grasping light*
> *And I trembled in my darkness.*
> *The angels spoke,*
> *Their gleaming figures wreathed in light*
> *And I longed to touch their shining.*
> *Then Jesus spoke,*
> *And light broke through my flesh and bone*
> *And wrapped around my heart.*

He showed us who God is by modeling how life should be lived. So many of us, trying to navigate the mysterious seas of life without him, struggle, reach, experiment, fail, and come to the end of it all with a sigh of frustration. How much better to follow our Savior's lead, he who has passed through it all and was victorious.

Jesus too expressed the inexpressible. At the tomb of his friend Lazarus, Jesus "groaned in the spirit" (John 11:33 KJV), and later, his sighs gave way to weeping (John 11:35). Life in our poor, fallen world, marked by sin, often leaves us bereaved and puzzled. But Jesus conquered sin once for all time by his death and resurrection.

One day, all the mysteries will be solved, all the tears will be dried. But for now, like Job we need not know the whys of this world's labyrinthine ways, but the who—who is in control and who will triumph when "God's last *Put out the Light* [is] spoken" (Robert Frost).

"In the world you will have trouble," Jesus said, "but take heart! I have overcome the world" (John 16:33). And so shall we, if we follow him in faith. Our last sigh will be one of satisfaction when we see him, the End and Joy of all our journeying.